LONG ISLAND
·········· *and* ··········
WORLD WAR I

LONG ISLAND
........ *and*
WORLD WAR I

Richard F. Welch

Published by The History Press
Charleston, SC
www.historypress.com

Copyright © 2018 by Richard F. Welch
All rights reserved

First published 2018

Manufactured in the United States

ISBN 9781467138888

Library of Congress Control Number: 2018932098

Notice: The information in this book is true and complete to the best of our knowledge. It is offered without guarantee on the part of the author or The History Press. The author and The History Press disclaim all liability in connection with the use of this book.

All rights reserved. No part of this book may be reproduced or transmitted in any form whatsoever without prior written permission from the publisher except in the case of brief quotations embodied in critical articles and reviews.

For "FJ" Francis Jerome Gray, OFM; Dave Costigan; John Born; Don Douglas; Bill Unrau; and George Collins—teachers, mentors and friends inside and outside the classroom.

CONTENTS

Acknowledgements 9
Introduction 11

Chapter 1. Slow Walking into the Maelstrom 15
Chapter 2. Camps and Training 28
Chapter 3. Protection and Production 41
Chapter 4. All In 55
Chapter 5. Suspicions, Apprehensions and Fears 66
Chapter 6. Over There 83
Chapter 7. Victory, Peace and Normalcy 98

Long Island's War Memorials: A Selection 115
Notes 121
Bibliography 133
Index 137
About the Author 143

ACKNOWLEDGEMENTS

Works of history typically bear the name of one author, but all are collaborative enterprises. This book would have been impossible without the assistance and cooperation of many individuals and institutions that readily shared their knowledge and expertise.

Many thanks to Julia Blum of the Cradle of Aviation Museum in Garden City and Timothy Green at Brookhaven National Laboratory for allowing me to borrow from their extensive photograph and artifact collections. Karen Martin, who does double duty at the archives of the Huntington and Three Village Historical Societies, was of immense help in making their Great War–related photographic and document holdings available. Robert Kissam, at the Huntington Historical Society; Caren Zatyk, director of the Local History Room at Smithtown Public Library; and Tracy Pfaff, director of the Northport Historical Society, were all generous with both their time and materials. Melanie Cardone-Leathers was similarly supportive in granting permission to use photographs and documents from the Longwood Public Library's rich Camp Upton Collection. A special nod goes to Ned Smith, director emeritus of the Suffolk County Historical Society library, and Wendy Polhemus-Annibell, current director of the library, for their enthusiastic aid in accessing materials from the society's many collections.

I gained much from the planning sessions, discussions, research and collegiality shared by the team that created the Suffolk County Historical Society's "Over Here, Over There" exhibition. To Victoria Berger, executive

Acknowledgements

director; Richard Doctorow, exhibit designer; and colleagues and friends Noel Gish and Dave Clemens, thanks for making it both rewarding and fun.

I am deeply indebted to Judith Lee Hallock for allowing me to quote from her grandfather's wartime diary, which has never been published. Many thanks to Susan Elizabeth Hallock for permission to use their grandfather's photograph.

A special note of gratitude goes to Robert Hughes, Huntington town historian, and Bill Bleyer, historian and author, who went above and beyond in critiquing this book's manuscript. Their pertinent suggestions and comments helped make this a stronger book.

Also, let me offer my appreciation to Banks Smither, Ryan Finn and the team at The History Press for their expert guidance and encouragement in transforming this book from manuscript into published book.

Special appreciation goes to Carolyn Jean Price. For lots of things.

Suffice it to say, any flaws are solely the responsibility of the author.

INTRODUCTION

Historians are fond of dividing the causes of war into two categories: background and immediate. The same might be said for historical studies. I'd like to say the remote causes of this book lie in conversations with World War I veterans who were still numerous when I was young. But at the time, I was far more interested in the more recent conflagration the nation had just endured. Compared to the Second World War, the Great War, now assigned its preliminary number, seemed antiquated—its veterans were listed on memorials few paused to read, and when seen in documentaries and newsreels, its participants marched, cheered, rallied or fought in the jerky, almost comical, movements of the early motion picture technology.

Instead, my appreciation of the Great War and its influences came from classes, discussions and research with the many excellent teachers with whom I studied in college and grad school. When I began my own academic career, presenting the world war to students deepened my conviction that this terrible convulsion was the key to understanding so much subsequent history. In short, experiences in front of or behind a desk or lectern were the remote or background causes of—perhaps latent inspiration for—this book.

What I discovered, and strove to impart, was that the Great War, later the First World War, was the transformative event of the twentieth century. Because of the war, four empires collapsed, and from their wreckage the modern countries of eastern Europe and the Middle East emerged. The war created the circumstances that made the Bolshevik Revolution possible, and

Introduction

the communist regime that took power in Russia as a result became a major force in world politics throughout the remainder of the century.

Many of the roots of the Second World War are traceable to the First. Perhaps the most important of these was the unleashing of virulent chauvinism, especially in Italy and Germany. Peoples under colonial domination, from Ireland to India to Africa and Indochina, began their often-violent march to independence. Women secured full rights of citizenship, and their mobilization in the workforce became a crucial component in the wartime economy of every belligerent nation. And the United States emerged as a global power.

American industrial and financial support between 1914 and 1917 was instrumental in maintaining the Allied war effort, and by intervening in the conflict when it did (and on the side it did), American participation determined the war's outcome. The nation's experiences in 1917–19, especially the heated debates over the peace treaty, informed American decision making during World War II and its aftermath. Drawing on lessons from the Great War, the United States took the lead in creating the United Nations, overcame its traditional fear of continuous foreign involvement and "entangling alliances" and assumed the leadership of the democratic nations during the Cold War.

Although my academic career primed me for undertaking a Great War–related project, it required something specific to turn predisposition into action—an immediate cause, if you will. That appeared with the approach of the centennial of the United States' intervention in the Great War in 2017. To commemorate this event, the Suffolk County Historical Society, Riverhead, Long Island, New York, decided to mount an exhibition on the experience of Long Islanders during the conflict, and I signed on as curator.

The exhibition, "Over Here, Over There: Long Island in the Great War," undertook to present the multifaceted experiences of Long Islanders in the context of national and international events. The project allowed me to combine my interest in the war with my lengthy involvement in local history. The exhibition, which opened in April 2017, presented the Long Islanders' war in its variegated forms—military and civilian, domestic and overseas, economic opportunities and social transformations. Drawing on the society's own collections, augmented by contributions from many generous individuals and institutions, the exhibition told the story of the war and Long Island through concise, accurate narrative, historical photographs, illustrations, documents, posters and a superb array of artifacts—weaponry, equipment, medals, decorations and commemorative pieces.

Introduction

Work on the exhibition triggered the decision to turn the project into a book. A written study would provide the opportunity to build on the exhibit and delve more deeply into how Long Islanders viewed, supported, participated and reacted to the experience of war.

This study explores the impact of the war from the perspective of a single area, the two independent counties of Long Island.[1] Although an extended part of the New York City metroplex, Nassau and Suffolk Counties exhibited a mixture of traditional and modern forms, boasting a healthy agricultural sector and small village businesses, even as modern industrial and commercial enterprises (and some early suburbanization) were making inroads into the counties.

Early twentieth-century Long Island resembled large parts of the American landscape, which was not yet exclusively dominated by giant cities and dependent suburbs. The Island may, in fact, be viewed as a microcosm of many sections of the country—especially those of the Northeast and Great Lakes Midwest, whose socioeconomic and political patterns loomed large in national importance. For this reason—though individuals, locales and some issues were specific to itself—Long Island during the years between 1914 and 1919 provides a case study for exploring the larger American experience during the Great War.

Along with the rest of the country, Long Islanders were directly affected by military service (willingly or conscripted), volunteerism, heightened (sometimes coaxed) patriotism, social coercion, suppression of dissent, economic and social transformation, triumph and loss, reaction and remembrance. How the citizens of Nassau and Suffolk experienced and viewed their wartime experiences reveals much about them and the nation at large. That is the subject of this book.

Chapter 1

SLOW WALKING INTO THE MAELSTROM

At the outbreak of war in Europe in 1914, Long Island had already assumed its contemporary political structure. The counties of Kings and western Queens, annexed by New York City in 1898, were increasingly integrated into the economic and transportation patterns of the urban metroplex. Eastern Queens, renamed Nassau County, and Suffolk County together composed about two-thirds of the Island's total land mass, remained independent. In 1910, Nassau counted 83,930 inhabitants, while just across its eastern boundary, Suffolk, with a much larger area, was home to 96,138.[2] Queens County, recently incorporated into the city of Greater New York, had a population of 284,041. The entire city, the nation's largest, boasted 4,766,883 residents.[3] Indeed, despite their political independence, Gotham's effect on Nassau and Suffolk was profound, providing employment, capital, recreation and communication directly to thousands of Long Islanders, as well as indirectly affecting virtually all its inhabitants.

While the Island's population was still centered on families present before the Civil War or earlier, the residential mix was affected by large numbers of more recent arrivals. The most conspicuous of these were affluent city residents, the era's "1 percenters." They were attracted by the Island's natural beauty, especially the rolling woods, and deep inlets and bays of the North Shore. As they had in the city and elsewhere, they constructed imposing homes commensurate with the wealth and position in society. Wide swaths of the North Shore were transformed from modest farming communities into large estates based on the English model, replete with huge mansion

houses, landscaped grounds and specimen plantings. The largest cluster of such estates was the "Gold Coast," an area that stretched from Kings Point to Huntington on the Long Island Sound coastline. Other concentrations of the nation's wealthy elite could be found at Old Westbury, south of the Gold Coast proper, and more spottily on the South Shore in places like Great River and the South Fork, later branded "the Hamptons."

The large estates provided employment for architects, landscape architects, skilled and unskilled laborers, nurserymen, gardeners, chauffeurs, mechanics, cooks and the like. Although never numerous, estate purchases provided an important revenue stream to local businesses. The galas, regattas, equine sports and automobile racing, organized by the estate owners, provided other sources of income for supporting trades and added to the Island's recreational and entertainment component. After the war, the lifestyles of Gold Coast elite, real or imagined, became the inspiration for F. Scott Fitzgerald's iconic *The Great Gatsby*.

The Island's physical beauty drew others as well. Entrepreneurial real estate developers began laying out communities designed specifically for young, upwardly mobile professionals who drew their income from the city. Designed for this middle-class demographic, such prewar developments, exemplified by T.B. Ackerson's Brightwaters on Suffolk's South Shore, featured quality homes on modest plots, landscaped streets and amenities such as a boat basin, bathing pavilion and parks.[4] The war had a depressing effect on the home construction industry, and the wave of suburbanization paused, then revived in the 1920s, before the Depression. The great surge of suburbanization that dramatically altered Long Island would come after the Second World War.

Demographically, Long Island—and indeed the city and the country at large—was predominately white, although relatively small black communities were long established in such places as Lake Success near Great Neck, as well as parts of Stony Brook, Setauket and East Hampton. The white population still retained strong elements of its pre–Civil War population, largely descended from Protestants from the British Isles, but in the decades since the Civil War, these had been joined by significant numbers of Irish, Italian and Polish Catholics, as well as, to a lesser extent, Jews. Although not as pluralistic as Manhattan and the city counties (or boroughs), Long Island's ethnic diversity was often more than met the eye and was reflected in the names found on the numerous community memorials erected after the war that listed those who served in the armed forces.

Long Island and World War I

Although its agricultural sector, including shell and fin fishing, was substantial and robust, the many villages contained commercial enterprises such as hardware and grocery stores, hotels, real estate offices, insurance brokers, banks and saloons. Others were home to small localized industries, tapping into the emerging technologies of electronics, automotive technology and, more exotically, aeronautics and aviation.

At the onset of European hostilities in August 1914, President Woodrow Wilson declared American neutrality, and the American public generally agreed. From the beginning, public opinion tilted sympathetically toward the Allies, especially Britain and France, for historical and ethno-cultural reasons. The large German-descended population tended to be more supportive of the Central Powers, the alliance anchored by Germany and the Austro-Hungarian empire.[5] Over time, sentiment favoring the Allies increased because of certain events, but many German Americans remained sympathetic toward their ancestral homeland up to the moment the United States declared war on Germany in April 1917. The numerous and politically influential Irish American communities, especially strong in urban Democratic politics, were inclined toward anti-British attitudes, and some of their organizations helped fund the Irish Easter Rebellion against Britain in 1916. Again, though, once the United States entered the war, they lined up in full support of the nation's cause.

Early involvement by Long Islanders in war-related activities involved humanitarian volunteerism. In 1914, German armies rolled over almost all of Belgium and a chunk of northwestern France. Americans organized relief agencies to aid orphans and refugees fleeing the German occupation. Others, more pro-Allied, joined the American Ambulance Field Service, which operated in combat conditions on the western and sometimes Italian fronts. Some Americans joined the British army through Canada. Most famously, American volunteer aviators formed what was first dubbed the *Escadrille Americaine*, which flew for France against imperial German air units. Protests from Germany and at home that the name implied a breach of American neutrality led the unit to change its title to the *Lafayette Escadrille*, the name by which it became famous. The American volunteers in these pre-intervention organizations were mostly college men from affluent, old-stock families, a pattern that continued to mark some volunteer units after the United States entered the war. The *Escadrille* aside, the participation of Long Islanders in these early efforts seems to have been confined largely to organizing and supporting the different relief agencies.

Americans followed the course of the war through newspapers, magazines, motion pictures and public speakers. Most of the news was slanted in a manner favorable to the Allies. This was partly a result of the British having cut the underwater cables between Germany and the United States. The sole means of direct communication with Germany was the *Telefunken* transmitter located in West Sayville on the South Shore of Long Island. The 480-foot tower was in operation by January 1913, communicating with a station in Nauen, Germany. When the United States announced its neutrality, the government prohibited the West Sayville station from transmitting coded messages, although it could serve as a source of news reports for both countries. Navy personnel were stationed on site to ensure that the Germans were not radioing potentially classified information. When intercepts from West Sayville indicated that the Germans were, in fact, using the station to send and receive sensitive information, the federal government took direct control of the facility, although German operators continued to receive standard war news from home.[6]

The government presence was increased in July 1916 when a detachment of Marines was sent to guard the facility and, no doubt, keep an eye on German activities. Finally, as the United States broke relations with Germany in February 1917, all German nationals were ordered off the site, which came under American military control for the remainder of the war.[7]

Although wireless transmissions kept German embassies, consulates and press agents in touch with their homeland, they never enjoyed the open flow of information that ran from the western Allies to America, allowing the Entente powers to control the narrative, and that gave them a relatively free hand in depicting the war as a contest between democracy and Prussian militarism.

War between the major European powers generated enormous demands for food, resources and military equipment. As a neutral nation, the United States was perfectly positioned to provide such materials. General concepts of international law allowed neutral nations to sell materials to warring powers on an equitable basis. However, the British unleashed their key weapon, the Royal Navy, blockading Germany (whose seacoast was relatively small), intending to strangle and starve the Germans into submission. Consequently, American trade with Germany fell precipitously, while trade with the Allied nations—especially Britain, France and, on a lesser scale, Italy—grew enormously. Between 1914 and 1916, U.S. exports to the Allies totaled $7 billion; $2 billion came directly from sales of munitions and $5 billion from foodstuffs, cotton, raw materials, metals and sundry manufactures.[8]

The nation, which had been in a deep recession at the war's outbreak, was booming by 1915 and would continue to enjoy economic prosperity throughout the conflict, a reality that became an inescapable consideration in government calculations.

American support for the Allies escalated as the costs of the war outstripped the Allies' ability to pay. By 1915, American banks, led by J.P. Morgan, were underwriting the Allied war effort. Morgan banker Henry Davison, a resident of Peacock Point on Long Island's North Shore "Gold Coast," led a consortium of financial institutions in underwriting an unsecured loan of $500 million—an amount just 20 percent less than the entire United States budget—for the Anglo-French governments.[9] By the war's ending in 1918, Morgan had arranged $1.5 billion in credits to the Allies.[10]

Nor was that all. After securing Morgan's selection as Franco-British purchasing agent, Davison and his partner, Thomas Lamont, created the Morgan Bank's Export Department to secure materials essential to the Allied war effort. Between 1915 and 1918, the Export Department contracted for $3 billion in military supplies, procuring munitions, small arms, corned beef, artificial limbs and much more.[11] The money drove profits—and employment—in firms such as Bethlehem Steel, U.S. Steel, Winchester and Remington Arms, major oil producers and meatpackers to rarefied heights. Additionally, Morgan money funded the creation of new factories to fill the Allies' insatiable demand for matériel. While essential to the Allies' ability to conduct the war, the arrangement was also highly lucrative for the Morgan Bank, which received a 1 percent commission on each contract it arranged. By the time of the Armistice, the Morgan bank had netted $30 million in profits for its services to the Allies.[12] American financiers, led by Davison and Lamont, effectively became the Allies' bankers and creditors. Concurrently, it left them—and the country—exposed to disaster in the event of German victory.

In contrast, efforts on behalf of Germany were paltry. Nevertheless, despite the difficulty of maintaining contact with Germany, by 1915, German Americans had raised about $10 million, mostly through the purchase of imperial bonds.[13] Additionally, German American groups organized fairs and fundraisers for the Fatherland's war efforts, with the money collected earmarked especially for the wounded and those on short rations due to the British blockade.

The flow of money, small arms, ammunition and food from the United States to the Allies led the German government to charge the United States with violating the spirit of neutrality if nothing else. Some individuals in the

Long Island and World War I

German American groups organized rallies and fundraisers in support of the German war effort. Pictured is a program from such an event held in Buffalo, New York, in 1916. *Author's collection.*

Wilson administration agreed, and there were larger numbers in the country who criticized the unrestrained American support for Britain and France. Such voices were generally ineffective against the reality of the economic boom, a benefit that neither Wilson nor his advisors wished to jeopardize. Although relatively few in or out of the government initially favored intervention, American public opinion was already tilted toward the Allies, and this sentiment would grow between 1915 and 1917.

Unsurprisingly, the Germans looked at the massive financial and economic support very differently. Aside from diplomatic protests, German agents attempted to disrupt the American efforts through argument, propaganda and sabotage. Most famously, a German agent placed a bomb in the munitions shipments piling up at "Black Tom," a small peninsula jutting out from the New Jersey side of the Statue of Liberty. On July 30, 1916, an enormous explosion virtually destroyed the facility and, with it, a massive amount of matériel. Remarkably, few were seriously hurt, but the general reaction in and out of government was that this was another item in a growing list of German outrages.

The great American grievance against Germany, the one that finally pushed the nation to declare war, was the issue of submarine warfare. With the German surface fleet bottled up by the British blockade, the Germans countered the British blockade with their submarines, the *unterseeboot* (usually shorted to U-boat in English). Their objective was to cut off Britain and France from the necessary supplies furnished by the British empire and, more significantly, the United States. The submarine was a new weapon, first developed in the United States, whose use effectively rendered obsolete the commonly understood rules of naval warfare, especially as it pertained to merchant vessels and civilian liners. The issue was further complicated by British countermeasures that utilized armed merchantmen, "Q-boats" and naval vessels disguised as passenger ships, as well as the transport of munitions

on passenger liners. Moreover, most officials in the Wilson administration argued that the presence of American citizens on merchant vessels or Allied passenger ships made them off-limits to attack. Not surprisingly, the Germans argued, and acted, otherwise. The sinking of the British passenger liner *Lusitania* and the loss of one thousand lives, including more than one hundred Americans, caused tremendous public anger in the United States and was deemed another example of German "frightfulness."

Wilson, who still hoped to maintain American neutrality despite growing pressures to enter the war, responded cautiously even as German U-boats sank more Allied vessels, costing civilian lives and violating what most Americans claimed as their rights to freedom of the seas as neutral parties. In May 1916, when it seemed that submarine warfare might lead to an open break with the United States, the Germans promised to rein in U-boat attacks and ordered their crews to follow the conventional rules of "cruiser warfare"—stopping a merchantman and allowing crews to evacuate the vessel before sinking it. The German pull-back gave Wilson a bump in popularity, although few noticed that the Germans also stated that if the United States could not prevent the British from violating international law, which they did on a regular basis, the German government would be forced to reassess the situation.

While Wilson did protest and sometimes took steps to counter Britain's more egregious violations of American neutrality, pro-Allied sentiment grew inside and outside the government. British actions affected American trade, while German submarine warfare cost lives. Nevertheless, majority public opinion had not yet reached the point of demanding intervention, although many voices, from ex-president Theodore Roosevelt to Wilson's own secretary of state, Robert Lansing, favored intervention on the Allied side. Wilson himself began laying out a formula for a general peace, principles that would evolve into the Fourteen Points. In the meantime, he attempted again to determine if there was any possibility of reconciling German and Allied objectives in a manner that might end the war. There was not. In 1916, as Wilson secured reelection on the slogan "He Kept Us Out of War" (a slogan that he did not formulate and about which he had misgivings), the nation increasingly embraced a campaign of "Preparedness."

The Preparedness movement was aimed at readying the United States for what growing numbers believed to be inevitable war. For some, strengthening the armed forces would act as a deterrent and dissuade any of the belligerent nations from provoking the United Sates. Most, however, had come to believe that war with Germany and the other Central Powers was

inevitable and that the nation needed to be ready to take an active, possibly leading, role in securing an Allied victory. One highly visible aspect of the movement was the growth of the voluntary "military camp" movement, often referred to as the "Plattsburgh Movement" after the largest and most successful of the encampments, located on the shores of Lake Champlain in northern New York. Organized and encouraged by General Leonard Wood, the camps invited young men to attend voluntary summer training programs where they would be introduced to the rudiments of military life and command. Since most of the attendees were college men from privileged backgrounds, the press dubbed them "Millionaire's Camps," a label organizers unsuccessfully resisted. Indeed, many who took part were scions of the nation's most distinguished families, Theodore Roosevelt's sons among them. The volunteers paid their own way and supplied their own uniforms, while the army provided tents, weapons and instructors.

During the June–October training season in 1916, the second year of the camps' operations, 12,198 men attended the six military training camps located in the Empire State.[14] Hundreds more attended camps at Gettysburg and Tobyhanna, Pennsylvania. Enjoying widespread public approval, many hoped, or feared, that Plattsburgh and its sibling camps would provide impetus toward a policy of universal military training. Others expected the camps to provide officers for a greatly expanded army capable of taking part in the European war.

Long Islanders got a closer look at the Plattsburgh-style volunteer camps when the army established a training camp at Fort Terry. Situated on Plum Island, just off Orient Point on Long Island's North Fork, Fort Terry hosted 1,200 youths from a variety of secondary schools between July 6 and August 10, 1916.[15] The Fort Terry encampment extended army instruction to lads under eighteen, widening the concept of military instruction to include a new age cohort. With boys coming from twenty-three states and 324 different secondary schools, camp supporters touted the democratic nature of the experience and attempted to deflect charges of elitism.[16] Like most of the voluntary units formed before the war, the attendees came largely from private schools in the East. Moreover, like the army itself, the camps admitted only white males. The movement's organizers prepared to establish a separate facility for black recruits if "a sufficient number enrolled and troops [for instruction] were available," but neither condition was fulfilled.[17]

The young volunteers received instruction in manual of arms, close and extended order drill, target practice, personal hygiene, camp sanitation, how to erect tents and rudimentary tactics. Because of their youth, they

Long Island and World War I

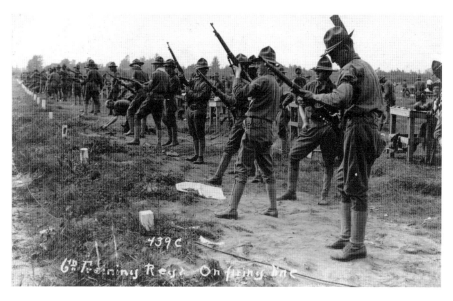

Rifle practice at the Plattsburgh Preparedness Camp, Plattsburgh, New York, 1917. *Author's collection.*

were granted ample time for recreation or visiting a large YMCA tent that served as the camp's social center. On Sundays, a ferry from Orient brought visitors to the camp.[18] Among the visitors was the patriarch of Long Island's most distinguished public family, ex-president Theodore Roosevelt, an increasingly harsh critic of Woodrow Wilson's neutrality and an outspoken advocate of preparedness and intervention. Inspecting the junior cadets on July 25, Roosevelt declared that "the man who isn't fit to fight for his country isn't fit to vote." He exhorted them to reject the arguments of pacifists, whom he described as "nice old women of both sexes."[19] The camps were deemed a success, with the potential for preparing a pool of young men who could provide effective service when they reached legal age to join the army. Although camps were planned for 1917, the outbreak of the war put them on hold, as the nation prepared camps of a more high-powered nature.

By 1916, "Preparedness" had ceased to be wholly voluntary. The Wilson administration, though still officially pursuing a neutral stance, could not ignore the growing pressures on the nation to enter the war. It became clear that the United States had to expand and strengthen its military capabilities if it were to play a major, if not decisive, role. In 1916, Congress passed the Army Reorganization Bill, which authorized the doubling of the army's size to 400,000 men and 17,000 officers, still far smaller than the forces

deployed by the major European belligerents. The National Guard was federalized, and guardsmen took dual loyalty oaths to both state and federal governments. The bill provided for a wartime draft, and following the lessons of the Plattsburgh Movement, a Reserve Officer Training Corps (ROTC) program was established. In August 1916, the United States approved the largest naval budget in its history, expanding the number of battleships, destroyers and submarines. Both income and inheritance taxes were raised to help defray the cost.

The inexorable drift toward war did not go unchallenged. On November 11–12, 1915, sixty-eight pacifists and social reformers from Great Britain and the United States met at the Garden City Hotel in Nassau County. The hotel, which had burned in 1899, had been rebuilt in a more grandiose form under the direction of celebrity architect Stanford White. It had become a favored watering hole of the New York and Long Island elite, but the peace advocates chose it because of its comfortable accommodations away from inquiring journalists in the city.

The meeting led to the creation of the American Branch of the Fellowship of Reconciliation, an organization originally founded in Britain. The establishment of the FOR was a seminal event in antiwar/social justice movements in America and influenced the creation of the National Conference of Christians and Jews, the Congress of Racial Equality and the American Civil Liberties Union.[20] The attendees, including Jessie Wallace Hughan, who founded the Anti-Enlistment League in 1917, signed a declaration pledging "not to sanction war in any form." They also expressed sympathy for the socialist critiques of the war's causes.[21]

Their original collegial approach became both more organized and overtly political after the United States entered the war, but their salient characteristic remained their unalloyed pacifisms. While they and their allies interceded for conscientious objectors and opposed such measures as government censorship, their efforts were overwhelmed by the wave of popular support for the war once it was declared.[22]

Ultimately, the United States entered the war against Germany over the issue of unrestricted submarine warfare and freedom of the seas. Realizing that time was working against them in the ongoing war of attrition, the German high command determined to knock the weakest of their major opponents, Russia, out of the war and transfer their eastern armies to the Western Front for a massive offensive. Simultaneously, they would unleash the U-boats to sink any vessel entering the waters surrounding the British Isles bringing supplies to the Allies. The idea was to strangle Britain while

German forces raced toward Paris. The Germans understood that the submarine assaults would lead to American entry. They gambled that the U-boats could cut the flow of American matériel to a trickle, sapping the ability of the British and French to continue the war. The reinforced German armies would then achieve victory on the Western Front before American troops and supplies could arrive in numbers sufficient to affect the outcome. They came close.

Mobilization

In February 1918, as the German U-boat campaign intensified in the Atlantic, the United States broke off diplomatic relations with Germany. Already incensed by the sinking of American and Allied shipping, the country was further outraged by the revelations of the Zimmermann telegram, in which the German Foreign Office broached the idea of drawing Mexico into a war with America with an eye toward retrieving territories it lost in 1848. On April 2, Woodrow Wilson formally asked the Congress for an official declaration of war, which was granted four days later.

Despite the efforts of the Preparedness movement and measures taken to beef up the armed forces, the nation was poorly prepared to wage war. While the United States had been providing enormous amounts of munitions to the Allies, it produced few modern artillery pieces for its own use. Its arms manufacturers were turning out rifles but few of the devastating machine guns that made combat on the Western Front so lethal. Americans had invented the modern airplane, but the country had done little to develop the technology for warfare. The navy was in somewhat better shape, but a massive expansion of warships and supply vessels was still needed. The country was also an enormous food producer, which was essentially keeping the western Allies fed, but now it would need greater production, not only for its wartime partners but also for its own vastly expanded armies.

The army fielded by the United States in 1917–19 contained three major components. The first ten divisions were composed of men from the regular army. A further ten divisions of regulars were projected, but these were never fully formed. The second group was drawn from the federalized national guards of the states. These included the 24th Division through the 48th Division. The 27th Division was essentially the New York National Guard, although some New York guard regiments found their way into other

divisions, such as the famous 69th (U.S. Army designated 165th Infantry), which was assigned to the 42nd or Rainbow Division. The remainder of the army, 76th to 93rd Divisions, was composed of draftees, the 77th Division being composed largely of draftees from New York State. During the war, some 2 million men entered the armed forces as volunteers, and another 2.8 million were inducted.

The draft, which had been highly controversial during the Civil War, was recast in the form of the Selective Service System. The new conscription program specifically proscribed the most unpopular provision of its Civil War ancestor: the purchase of substitutes or a payment of $300. Additionally, the Selective Service System was run by local officials, a measure designed to give the process a less authoritarian face. As a preliminary step to calling men to the colors, both New York and federal authorities implemented a military census of the state. All males twenty-one to thirty-one were initially liable for United States service. In August 1918, the cohort was expanded to include all males between eighteen and forty-five. The federal census was conducted on June 5, 1917, with potential inductees directed to report to their polling places, where a combination of sheriff's department, county clerks and county health departments conducted the registration. New York cast a wider net, not only enumerating males nineteen to twenty-five but also creating separate categories for boys sixteen to eighteen and women sixteen to sixty-four. All names were sent to Albany so "the state will be able to make the most intelligent use of 7,500,000 citizens in whatever line of work can be done most effectively."[23] While the state numbers could be used as a supplement to the federal count, New York authorities were primarily thinking of local defense and militia use and, in any case, never called up women for official enlistment. Although frequently discussed, military training for boys sixteen to eighteen remained mostly in the planning stage.[24]

State manpower quotas were subdivided into county requirements, and county officials usually created drafting districts. Suffolk County was divided into three districts: the first covered the towns of Huntington, Babylon and Smithtown, the second Islip and Brookhaven and the third the five East End towns. As was the case nationally, twice as many men were called as would be needed, as it was expected that many would seek exemptions based on marital status and dependents, war work or disqualifying medical conditions.[25] Provisions were established, after considerable debate, for conscientious objectors, mostly members of pacifistic sects. Those deemed eligible for military service could appeal to the next higher level, a right that the government also enjoyed.

All levels of government worked to present the draft and other forms of war service in a favorable light, and many civic, social, religious and professional organizations joined the effort. So did almost all newspapers and magazines, some socialist or explicitly pacifist publications excepted. As preparations for the draft got underway, the *Long-Islander* explained:

> *The selective draft has an advantage over the volunteer system in that those young men will be taken who can best be spared. Those having families dependent on them or who are markedly efficient in the manufacture of munitions or able experts in other branches of industry necessary for the support of the nation will not be drawn in until the other classes are exhausted, and in this way the fullest power of the country may be exerted for the benefit of the common cause.*[26]

A few months later, the paper's editorialists comfortably explained that "the greater parts of those who are not killed in battle or seriously wounded will return improved in health and courage for taking up the duties of life."[27] Other expected benefits of the draft included the Americanization of immigrants and first-generation Americans, a widespread concern among those uneasy about the heavy immigration the country had experienced from the latter decades of the nineteenth century.

Other benefits were expected. Many Americans, especially skilled workers and the middle and upper classes, were fearful of the extent of labor violence, as exemplified by the radical Industrial Workers of the World. Some predicted that military service would instill a sense of patriotism, making returned veterans "uncompromising opponents of the I.W.W.s....They will be a body of inestimable value in defending the country from attack from without and lawlessness within."[28]

As the ranks of the army began to swell exponentially, military and civilian authorities prepared camps and training grounds to prepare them for their tasks. Some bases had been in existence for many years, even decades. But they were clearly inadequate for the number of men projected to enter the country's armed forces. New training camps, like the army itself, would be created from scratch.

Chapter 2

CAMPS AND TRAINING

Training the millions of men for service in the largest army and largest war in the nation's history became a top priority. Regular troops were to be placed in 1st Division through 20th Division, although only the first eight were fully operational when the war ended. Their training centers were scattered around the country. The state national guards, 24th Division to 42nd Division, trained mostly in existing camps in the South. The New York National Guard, which became the 27th Division, was readied at Camp Wadsworth, near Spartanburg, South Carolina, although a few regiments were assigned elsewhere. Sixteen entirely new training centers were constructed to receive and prepare the draftees who composed the new "National Army," almost all in the North. Long Island would be the site of one of these immense camps.

One of the first units to ready itself for combat on Long Island was the Yale Aero Unit, which was absorbed into the navy as the Naval Reserve Aero Squad soon after the nation declared war. The public and the press called it "the Millionaire's Unit." The squadron emerged from the enthusiasm of the Preparedness movement, which drew its adherents disproportionately from the nation's financial and educational elite. Attracted to the new technology of aviation, a group of Yale men, mostly from the crew team, learned to fly on their own time and expense.

Several members of the unit had family homes on North Shore Long Island's "Gold Coast," which became the center of their early activities. Trubee Davison, the son of Morgan banker Henry Davison, took the lead in organizing the collegiate aviators. His family's home on Peacock Point

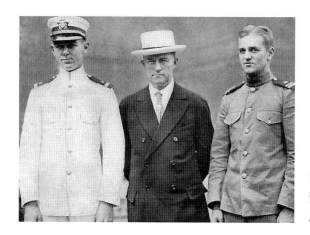

Harry P. Davison with his sons, Harry Jr. and Trubee. Peacock Point, Lattingtown, circa 1917. *Author's collection.*

in Lattingtown served as the group's headquarters during the summer of 1916, when they traveled to nearby Port Washington to acquire aviation skills on "flying boats." They were sufficiently confident of their abilities to name themselves the Yale Aero Club that autumn and demonstrated their proficiency by taking part in navy maneuvers off New York City and Long Island in 1916.[29]

When war was declared in 1917, the group was absorbed into the navy as the Air Reserve Squadron. The men trained first at Palm Beach, Florida, in April–May 1917 and then moved back to Long Island, where they honed the skills required for the ultimate test in Europe.

The Yale flyers constructed a new base on the Castledge estate, Oak Hill, located on Huntington Bay. This permitted easy access to both Long Island Sound to the north and the Atlantic Ocean only a few minutes of air time to the south, an ideal situation for training as navy pilots.[30] The young men were frequently seen in Huntington village, where they entertained their dates or stepped out for a restaurant dinner. They also helped launch a "Girls' Radio Unit," made up of female members of the upper crust who studied wireless communication and code.[31]

The "Yalies" lent a hand to the air wing of the New York Naval Militia, a naval counterpart to the National Guard. The Naval Militia was stationed on a small base across the Island at Bay Shore but originally had no aircraft in which to train. While they waited for their own planes, the naval militiamen drove up to Huntington Bay, where the Yale men gave them some flying instruction.

On July 28, 1917, the first of the Yale unit's pilots made their qualifying flights under navy supervision. Those who passed received their wings and

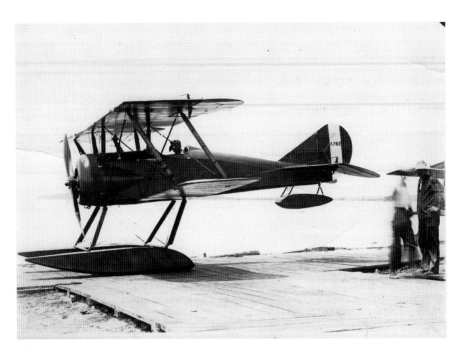

Curtiss HS-IL Flying Boat at the Yale Naval Air Reserve unit base, Huntington Bay. *Courtesy of the Huntington Historical Society.*

Originally a New York Naval Militia post, Bay Shore became the site of a Navy Air Reserve Station during the war, 1919. *Courtesy of the collection of Noel Gish.*

ensign's commissions. Tragically, Trubee Davison, who had been the driving force behind the squadron's creation, crashed during his navy qualification test. His legs were badly injured, and he became the only member of the group not to see active service. The other members began leaving for Europe in August, and they were deployed with the British at Dunkirk on the English Channel. By August 30, they were flying reconnaissance patrols and escort protection for Allied shipping. In time, they would see deadlier work.[32]

On July 14, 1917, before departing for the war zones, the Yale unit participated in a Red Cross fundraiser—a baseball game at Peacock Point that pitted them against a team from Hazelhurst Field in Mineola. Hazelhurst, organized in 1916, was one of two army aviation bases situated outside the village of Mineola, located almost dead-center in Nassau County. Originally divided into a Hazlehurst One and Hazlehurst Two, the second field, just south of One, was renamed Mitchel Field in honor of New York City mayor John Purroy Mitchel, who had been killed in a flying accident. The field's location was determined by the topography of the area—a flat, brushy grasslands, originally known as the Hempstead Plains, that was ideally suited for an airstrip. Hazelhurst and Mitchel trained Army Air Service flyers and support teams throughout the war. After the conflict ended, Hazelhurst was renamed Roosevelt

Six Curtiss JN-4 "Jennies" at Hazelhurst Field, Mineola. *Courtesy of the Cradle of Aviation Museum.*

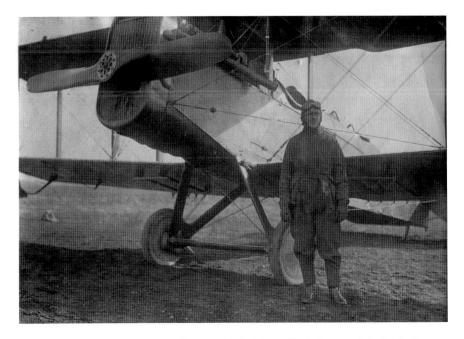

Army Air Service pilot and his De Havilland, Hazlehurst Field. *Courtesy of the Cradle of Aviation Museum.*

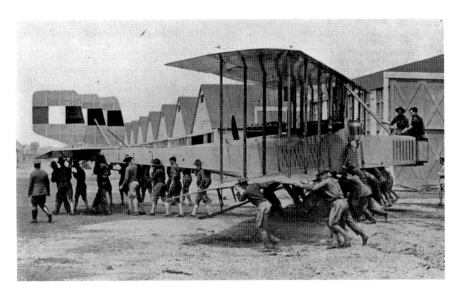

Hazlehurst Field airmen roll out an Italian Caproni bomber. *Courtesy of the Cradle of Aviation Museum.*

Long Island and World War I

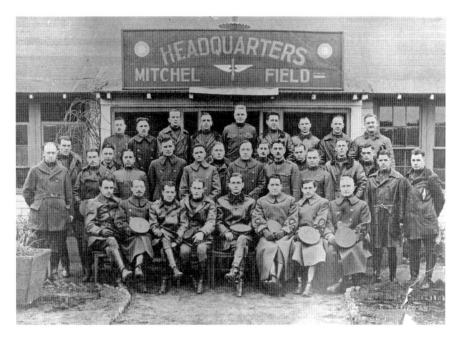

Officers at Mitchel Field, Mineola, 1919. *Courtesy of the Cradle of Aviation Museum.*

Field in honor of Theodore Roosevelt's youngest son, who was shot down and killed in air combat in July 1918.

Following the declaration of war, the army laid out two other, somewhat smaller airfields on Long Island. One was constructed on the South Shore near Wantagh and was christened Lufbery Field in honor of aviation ace Raoul Lufbery, who had flown in both the French and American air services. Four hundred men were stationed there when hostilities ended.[33] A unique aspect of Lufbery was its use of the nearby waters as practice ranges for bombing and machine gunning. Black-and-white buoys marked off target areas, which may have been good for the flyers but denied local baymen access to some of their prime oyster bottoms. Although they understood the need for the measure and were compensated by the government, the shellfishermen were happy when the field—and its watery range—was closed after the war.[34]

Brindley Field, the second of the two smaller aviation facilities, was situated in Commack, about twenty miles east of Hazelhurst in Suffolk County. The approximately ninety-eight-acre tract was opened on June 15, 1918, and was originally home to the 211 Aerial Squadron, commanded by Captain Richard H. Terry. Like its companions to the west, Brindley was

chosen for its flat, near treeless terrain. Brindley flyers even had the use of local luminary Carll S. Burr's private horse track to use as a landing strip.[35]

While it did not boast an official flying field, Amityville on the South Shore was chosen as a testing site for an unusual experimental weapon. Lawrence Sperry, aeronautical pioneer and later founder of the Sperry Gyroscope Company, had designed what he dubbed an "aerial torpedo." The device consisted of an unmanned Curtiss scout plane launched from a vehicle and controlled in the air by gyroscopic controls. Still in the navy, although unable to fly due to the injuries he had suffered in his qualification flight, Trubee Davison acted as the official observer. The "aerial torpedo," effectively a primitive guided missile, took off from a moving truck and flew out of sight over the water. It failed to hit its target and was never seen again. Although Sperry tested several more such weapons in 1918, none was successful. Fully operational—and deadly—guided missiles would have to await the next war, when the Germans unleashed their V-1s and V-2s on the world.[36]

In August 1917, the army established an infantry facility, Camp Mills, immediately south of Hazelhurst Field. Mills, situated at Camp Black (a Spanish-American War site), was selected as the training center for a unique National Guard division, the 42nd. Instead of the usual practice of organizing guard divisions from one or sometimes two states, the new 42nd incorporated regiments from several states, giving rise to its nickname the "Rainbow Division," a reference to the nationwide composition of the troops. When American divisions selected insignia later in the war, the 42nd very logically adopted a rainbow pattern.[37] Among the regiments that trained at Mills was the 165th United States Infantry, or the 69th Regiment of the New York National Guard, the designation by which it preferred to be known.

The 69th was traditionally a heavily Irish Catholic unit, and this character continued into the First World War. Additionally, it had carved out a record of hard fighting in the Civil War, when it was the nucleus of the famous "Irish Brigade." Despite being only twenty-five miles from Broadway, the agricultural and rural environment of Camp Mills was a shock to many of its Manhattan-bred volunteers. One soldier remarked that the whole area was "farmland inhabited by rabbits and skunks."[38]

Among the other guard regiments making ready at Mills was one from Alabama. It quickly became common knowledge that the 69th and the Alabamans had faced each other at opposite sides of the front at Gettysburg, and some of the men relived their grandfathers' histories with fistfights. Fortunately, the 42nd was one of the first American divisions sent to France in the autumn of 1917, which allowed the New Yorkers

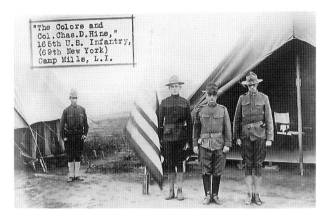

Left: Officers of the 69th New York/U.S. 165th Infantry, at Camp Mills, Mineola, Long Island, summer of 1917 *Author's collection.*

Below: Probably staged, here soldiers dance with young women at Camp Mills. The photograph was taken during a weekend visitation day. *Author's collection.*

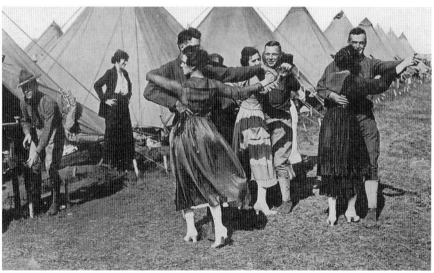

and Alabamians to forget past disputes and channel their aggressions against a more current enemy.[39]

Largest of all military installations on Long Island was Camp Upton, one of the sixteen newly built installations constructed out of scratch to house members of the National Army. Upton, named for Civil War general and military theorist Emory Upton, was to be a training center for draftees from New York State, especially New York City and surrounding counties. The camp's location was much farther east than Mills or the air strips, being gouged out of the pine barrens roughly between Yaphank and Calverton, with the former becoming most closely identified with Upton. The camp was composed of about ten thousand acres, with the capacity to house forty

thousand. Work commenced in the summer of 1917 and was completed enough to greet the first wave of draftees in September.

Proximity to the small hamlet of Yaphank provided the inspiration for Irving Berlin's musical tribute to army life, *Yip Yip Yaphank*. Berlin, already a budding songwriter, was introduced into the regimen of army life at Upton. The not always enjoyable process was lampooned in his enduring "Oh, How I Hate to Get Up in the Morning," which he wrote for the show.

Constructing Camp Upton was a prodigious undertaking. The pitch pine and scrub oak forest had to be cleared and roads, barracks, mess halls, officers' quarters, sewage and electrical systems installed. A link from the Long Island Railroad's main branch brought in the necessary supplies and equipment, as well as the freshly inducted men, who became the 77th Division. The division later chose the Statue of Liberty as its insignia in commemoration of its home state and region. In addition to the military structures, completed by a small army of civilian laborers, non-government support groups including the YMCA and Knights of Columbus erected meeting halls and recreational rooms for the troops, facilities they had already set up at Camp Mills and its adjoining airfields.[40]

The war had been a boon to the nation's economy for more than two years, and the military installations were a tonic to local businesses,

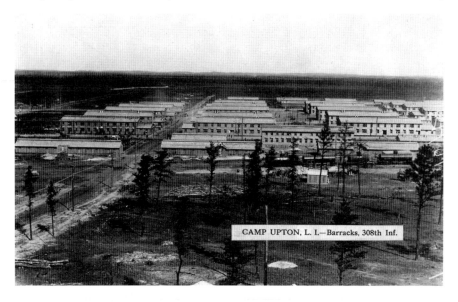

Aerial view, Camp Upton. The camp was constructed from scratch in the pine barrens of eastern Long Island during the summer and early fall of 1917. *Courtesy of the Longwood Public Library's Thomas R. Bayles Local History Room.*

tradesmen and workers. Upton, in particular, because of its size and newness, provided a major boost to the East End economy. As Riverhead's *County Review* observed, "the big Camp Upton means a lot of trade here [Riverhead]. Our merchants are quick to take advantage of the situation....They have already taken steps to make travel from the camp to Riverhead easy."[41] Indeed, the Riverhead Town Board soon allocated $2,500 to improve the road from Upton to the village and regularized taxis and buses conveyed trainees to and from Riverhead.[42]

Riverhead and other area communities hoped to lure soldiers with weekend passes to their restaurants, hotels, movie and live theaters, festivals and the like. As was true in other villages near the military bases, Riverhead also established special recreation and leisure centers for visiting troops. Many soldiers sought other amusements, especially alcohol, although the army prohibited saloons within a five-mile radius of Upton and sometimes took stronger steps to suppress illegal sales of beer and spirits to the young troops. Regulations designed to prevent alcohol consumption were standard throughout the country and were also in force at Camp Mills and Brindley, Hazelhurst and Mitchel Fields.

Of course, the new troops were put through rigorous training to prepare them for what they would meet in Europe. This was largely directed by American officers, but a smattering of British and French officers, who had front-line experience with the realities of modern warfare in Europe, sometimes took a hand. While the 77th Division was the largest single unit to train or be stationed at Upton, it was not the only one that found a home, however temporary, in Long Island's Pine Barrens. While the recently inducted men of the 77th were introduced into the rigors and rituals of military service, the camp itself was guarded by members of the 15th New York National Guard, an all-black unit. Other regiments occasionally passed through the camp, and convalescent soldiers were sometimes quartered there. As troops returned home in 1919, Upton also functioned as a convalescent and discharge station.

While Camp Upton was situated in a sparsely inhabited part of the Island, it was by no means isolated. Soldiers securing weekend passes could take the Long Island Railroad into New Yok City if they desired amusements greater than what the local villages could provide. Volunteers at the YMCA and Knights of Columbus centers traveled in and out of the camp, and family members or friends could visit the camp on weekends. Social leaders, entertainers and, of course, politicians regularly made their way to the nation's forts, fields and camps, and Upton was no exception. In November,

Long Island and World War I

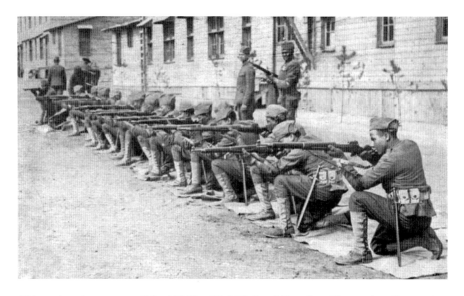

African American troops of the 15th New York National Guard at rifle practice, Camp Upton. *Courtesy of the Longwood Public Library's Thomas R. Bayles Local History Room.*

former president Theodore Roosevelt, long an outspoken proponent of both preparedness and intervention, motored from his home at Sagamore Hill in Oyster Bay to the military village at Yaphank. Roosevelt was treated to infantry and artillery demonstrations and made several addresses to the troops. Speaking to the draftees, he drew an enthusiastic response when he opined that all officers should rise from the ranks and that no one should be admitted to West Point or Annapolis without first serving as a private.[43]

As the army was racially segregated, Roosevelt was given use of the Knights of Columbus center to make a separate address to members of the 367th Regiment, which had been formed from the all-black 15th New York National Guard. He recounted the exploits of the African American 9th and 10th Cavalry regiments with which he served in Cuba during the Spanish-American War. Addressing concerns that their service in the current war might go unappreciated, he told the men that Upton's commandant, General Franklin Bell, "would see justice done to every man"; Bell himself stepped forward and emphatically affirmed Roosevelt's statement.[44] Whether prodded or not, the troops serenaded Roosevelt with what were considered African American songs, including "Old Black Joe." Roosevelt then asked officers from black regiments who had fought in Cuba to step forward, taking their hands and reminiscing about the earlier war.[45] Although Roosevelt, and

probably Bell, were sincere in their promise that troops would be treated equally regardless of race, the reality in both the United States and France fell well short of the mark.

Clearly enjoying his visit, Colonel Roosevelt, as he preferred to be known post-presidency, told another group of young recruits crowding around the visiting dignitary, "By George, I'm more pleased than I can say, and I'll bet on you against any sauerkruaters that were ever born."[46] Nor was that all. Although the *County Review*'s reporter diplomatically stated that he was "sturdier in appearance than ever," Roosevelt proceeded to the YMCA auditorium, where he addressed yet another group of waiting soldiers, telling them they were ready to meet "the call of your country" as had their forebears in Washington's and Lincoln's times.

Roosevelt then turned to an issue that cut to his code of core American values: manhood and courage. "The man who hasn't fitted himself to be a soldier," he declared, "and the woman who hasn't raised her boy to be a soldier are not entitled to the suffrage. Conscientious objectors are nice enough people, I suppose, if your tastes incline you to like sissies, but I don't myself regard the male sissie as a useful member of society."[47] Roosevelt went on to divide conscientious objectors into two classes: those afraid for their lives and those who had moral objections to taking the lives of others.

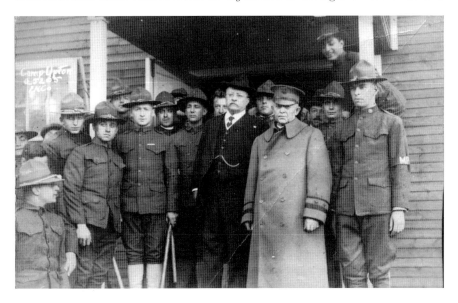

Theodore Roosevelt visiting the troops at Camp Upton. Camp commandant General Franklin Bell stands at his left. *Courtesy of the Longwood Public Library's Thomas R. Bayles Local History Room.*

The first he thought could be set to work digging trenches, while the latter might be fitted for such service as mine sweepers. Having unburdened himself with his views on manhood, women's roles and pacifism, the ex-president returned to his vehicle for the long trip back to Oyster Bay.[48]

After six months of training and preparation, with the men becoming increasingly itchy to see the real war, the 77th shipped out to France in March 1918. Although some troops remained quartered there or were temporarily posted on return from France, Upton seemed a hollowed-out facility to many observers. Its most significant contribution to the national war effort was indeed over, but it had completed the mission for which it had been designed.

The 69th New York was the first New York unit to sail across the Atlantic to the war zone. Its parent division, the 42nd, was one of four divisions that composed the initial complement of the American Expeditionary Forces. On October 17, 1917, shortly before they embarked on the transports waiting in New York Harbor, the regiment held a farewell dance at the Garden City Hotel. They ended the evening with the tune "Send Me Away with a Smile."[49]

Chapter 3

PROTECTION AND PRODUCTION

As the exiting national guard units were scheduled to be incorporated into the army by summer, concern grew about the means available for state and local governments to deal with situations beyond the capabilities of state and local police and fire departments. The solution was the formation of Home Guards or Home Defense Units, associations of volunteers drawn from older men and those exempted from the draft.

In New York, Governor Charles Whitman called on towns and counties to appoint home defense committees to oversee the creation of the guards. In Suffolk County, the sheriff took the lead in establishing the local defense force, a measure that was widely supported.[50] The only controversy entailed cost. The army was expected to provide rifles and, usually, accoutrements. In practice, however, towns sometimes furnished weapons. The men were expected to provide their own uniforms, and they, in turn, assumed that the citizenry would foot the bill. The Suffolk County Board of Supervisors declined to accept the financial burden and left it to the separate towns to assume the cost, which they did, though possibly with a certain amount of grumbling.[51] Training was provided by National Guard officers who had not been called into wartime service.[52]

In May 1917, the state incorporated the local Home Guard detachments into the New York Guard, which was intended to replace the federalized regiments. The men enlisted for a term of two years, taking an oath to the state but not the national government.[53] Addressing the thirty to forty men who joined the Home Guard company in Huntington, Major C.B.

Long Island and World War I

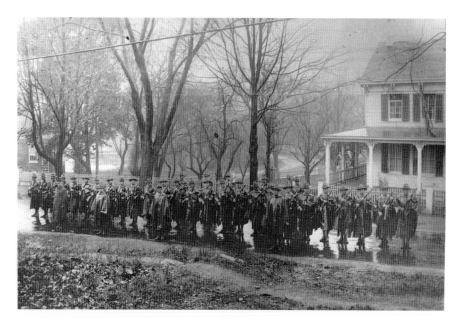

Cold Spring Harbor Home Guards muster out, 1918. *Courtesy of the Huntington Historical Society.*

DeBevoise of the local reserve cavalry command explained that they would deal primarily with "ensuring the main arteries of travel are kept open, so that the material consigned to the Allies, both food and munitions, are safely passed through New York State."[54] Governor Whitman assured Home Guard enlistees that they would be dispatched outside their own counties "only in critical situations." However, he cautioned, "in case of emergency, riot or insurrection anywhere in the state, I shall use whatever military force…to proceed at once to that locality and assist in suppressing such disorder."[55]

Major DeBevoise reiterated this provision when he spoke to the Huntington Guards later in September, by which time the state had decided to maintain two provisional regiments, composed of volunteer units from throughout the state, to provide a permanent force to protect such sensitive points as bridges, aqueducts, railroad terminals, war-related industries and the like. The remainder of the guardsmen would be called out only for "strike duty and extraordinary disturbances."[56]

Indeed, some influential voices seemed to believe that the Home Guards would be used as much against radical labor organizations, especially the IWW, as any possible German threat.[57] In the May 21, 1917 edition, the *Long-Islander* laid out widely held fears:

With the large and constantly growing turbulent class in our country of I.W.W.s, Anarchists, lawless trade union strikers and their sympathizers who hesitate at no overt acts of incendiarism or maiming or killing others who will not submit to their methods, it is necessary that we should have at all times in the Country an organized military force ready to promptly quell riots or other disorders in their incipiency. They will largely take the place of the National Guardsmen who are soon to depart for the War.[58]

Like many voluntary and patriotic organizations, the Home Guards played a prominent role in holiday celebrations, recruitment drives and fundraisers. For example, South Fork guard companies hosted a dance at Clinton Hall in East Hampton in May 1918 that drew five hundred participants. The Home Guards appeared in uniform, as did several local men from Camp Upton who had secured passes for the event. The highlight of the evening was the "Grand March" led by Major and Mrs. Dyer, followed by other officers and their partners. Miss Marion Holmes, costumed as the "Goddess of Liberty," appeared on stage with a soldier on her left and a sailor on her right. After she unfurled "Old Glory," the guards, soldiers, sailors and civilians joined together in singing "The Star-Spangled Banner."[59]

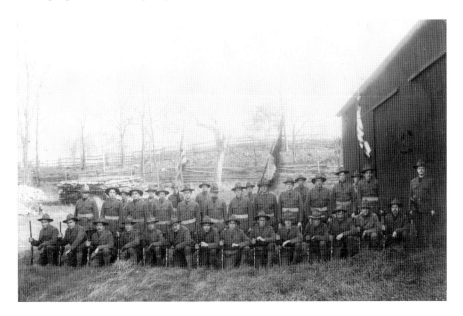

Cold Spring Harbor Home Guards training on farmland along Goose Neck Road. *Courtesy of the Huntington Historical Society.*

Long Island and World War I

The State Guards, as the collective Home Guards were titled, numbered about eight thousand men by the summer of 1918 and seem to have spent their time in drills, festivals and relatively uneventful guard duty. New York also outfitted a much smaller "Naval Militia" that, like the Yale men's Naval Aviation Reserve, was volunteer based. Publisher Russell Doubleday of Garden City provided much of the impetus for the Naval Militia, holding recruiting meetings, effectively rallies, at different spots on the Island, including one in Huntington in August 1917. The Naval Militia never approached the numbers and visibility of the Home Guard movement, and its activities were infrequently reported.[60]

Although intended as an emergency reserve force, Home Guards were sometimes deployed to provide security for military installations and businesses engaged in the production of military equipment. After war was declared, the demand for military equipment, and the materials and transportation links to produce and convey them, expanded exponentially. The nation's economic boom, already stoked by Allied purchases, went into overdrive. The New York metropolitan region contained many war-related industries and facilities providing the munitions, weaponry, uniforms, tents, shoes and related matériel for America's rapidly expanding armed forces. Installations like the Brooklyn Navy Yard were active around the clock, repairing and constructing vessels to defeat the U-boats and protect the convoys bearing troops and supplies to Europe.

The Island had nothing to match the shipyards in Brooklyn and elsewhere, but smaller local firms joined the hunt for government contracts nonetheless. Greenport's Eastern Shipping Company submitted a bid to construct two patrol boats at $50,900 each, while the Greenport Basin and Construction Company offered to build two submarine chasers at $49,995 apiece.[61] The following November, Greenport Basin and Construction won a contract to build two launches for the E.W. Bliss Company.[62] Bliss, whose headquarters and factory was in Brooklyn, was the nation's leading producer of torpedoes for the navy. In 1891, the company selected Sag Harbor on the South Fork as the base of its testing operations. Torpedoes were shipped from Brooklyn to Sag Harbor on the Long Island Railroad and then loaded onto launches and tested on ranges laid out on Noyac and Shelter Island Bays. At its peak of wartime operations, the Sag Harbor facility employed about seventy-five people.[63]

Throughout the nineteenth century, several villages on Suffolk County's North Shore enjoyed success in the production of wooden ships. However, with the shift to metal-hulled vessels and the supplanting of sail by steam,

Long Island and World War I

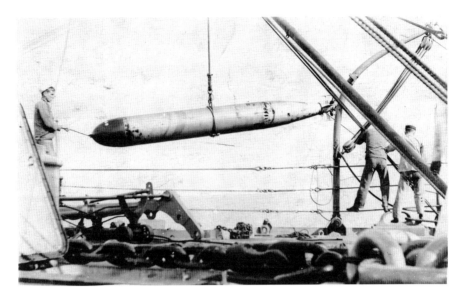

The Bliss Torpedo Company tested its weaponry at its Long Island facility in Sag Harbor. This prewar photograph depicts a Bliss torpedo being loaded onto a battleship. *Author's collection.*

the industry had faded and was largely a memory by 1900. The national demand for vessels of all types created by the war led to a brief resurgence of the industry in Northport and Port Jefferson, the latter having been the major center of Long Island's wooden ship trades.

In 1917, James E. Bayles, who had owned the most prominent shipyard in the heyday of wooden vessels, sold his holdings to the Smiley Steel Corporation. Smiley, in turn, secured a contract from the Emergency Fleet Corporation to renovate the yard for steel-hulled ship construction. The Emergency Fleet Corporation, the federal agency charged with creating a merchant fleet adequate for wartime needs, also bought two other former wooden shipyards: Mather and Wood and the John Hawkins operation. All three were folded into a single operation under the name Bayles Shipyard. The name was a nod to local pride and recognition, as the Bayleses had no hand or stake in the operations. Along with the money derived from the twenty ships of the North Atlantic Fleet stationed on the Sound just outside the village, the Bayles Shipyard provided a heady, if temporary, dose of prosperity to the community.

Between 1917 and 1920, the Emergency Fleet Corporation pumped $7 million in the Port Jefferson operation.[64] The output did not appear to justify the expenditure. Indeed, the vessels themselves were not ready

for launching until 1919, when the war was over. Two seagoing tugs, five freighters of 5,000 tons each, a 1,200-ton tanker and two scows slid off the ways into Port Jefferson Harbor. The low turnout was ascribed to the lack of experience with steel ships on the part of the local workforce, as well as waste and inefficiency on the part of the Emergency Fleet Corporation.[65] In 1920, the Bayles Shipyard was sold to the New York Drydock Company, which completed the ships under construction. It then broke up and sold off the entire operation. Yard No. 2, the former Mather yard, was taken over by the Port Jefferson–Bridgeport Ferry service, while the old Hawkins yard on the west side of the harbor was purchased by the Long Island Lighting Company. The Bayles yard, which had given the wartime operation its name, became a boat basin, restaurant and municipal center.

Northport's participation in the wartime shipbuilding revival was less impressive and even shorter. The Jesse Carll Shipyard, for fifty years the village's most important, had also gone into a steep decline after 1890. During the war, Jesse Carll Jr. leased his facilities to a firm that had secured a contract to build scows for the navy. Two were completed, and one was on the ways when the war ended. Work ceased immediately, and the yard reverted to Carll, who, facing the inevitable, abandoned the business. He donated the property to the village for use as a park, which remains a gem in Northport village to this day.[66]

The various war-generated enterprises drove up demand for workers, not only for the more visible industries like shipbuilding but also for less dramatic tasks. Under the title "Be a Patriot," the firm of Shebar & Klein in Freeport advertised for "100 Girls" needed for sewing work on government contracts.[67]

Many small businesses found ways to tap into the torrent of money injected into the economy by the government. Some ambitious businessmen marketed their products and services under a new guise, playing on the circumstances created by the febrile wartime atmosphere. The Manetto Hill Nurseries began its spring advertising campaign by encouraging Long Islanders to "Plant a War Garden."[68] Others played on early fears of German military action. Clarence A. Edwards, the "Insurance Man" in Freeport, invited the public to "Get My Rates for Bombardment, Explosion and Full War Risk" insurance.[69] Apparently, there were few takers, as Edwards never offered bombardment insurance again. It is possible he was told that suggesting the United States could not prevent the Germans from shelling its shores was unpatriotic, which was bad for business.

Long Island and World War I

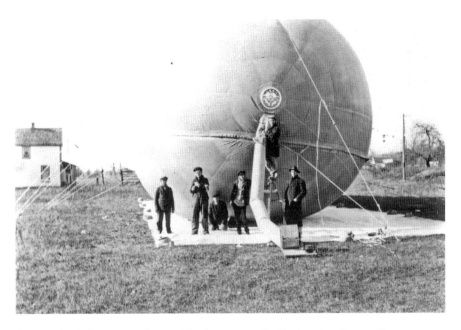

Observation balloons manufactured for the army at the Knabenshue Factory, East Northport, 1918. *Courtesy of the Northport Historical Society.*

Probably the most valuable and essential of Long Island's products was among its oldest: food. Even before the country entered the conflict, American food had become crucial to the ability of the Allied nations to continue the war, not to mention being increasingly profitable for its producers. This was especially true for the island nation of Great Britain, which depended on American agriculture to keep its armies and civilian population fed while they sought to starve Germany through a naval blockade. As the *Long-Islander* observed in May 1917, the United States had to feed "our own population herded in the big manufacturing and commercial cities of the country, and smaller cities and villages, a population swollen by demands of the munition plants of the country, [while] saving from starvation the suffering millions of France, Belgium, Armenia, and Great Britain."[70] A notice in the *Nassau County Review* the same month put the matter more succinctly: "Plant, Plant, Plant."[71]

The United States government created several special agencies to coordinate and regulate key sectors of the economy to nationalize the war effort: the War Industries Board, U.S. Shipping Board, Emergency Fleet Corporation, Railway Administration and the Selective Service System. Food production came under the oversight and management of the United

States Food Administration, headed by Herbert Hoover, whose work with the Belgian Relief Commission had been widely applauded.

The Food Administration's efforts relied on volunteerism, both through exhortation and sometimes social coercion. Increased production and decreased consumption were its objectives, and volunteer social organizations promoted "meatless" and "wheatless" days, as well as encouraging all who could to create or expand gardens. Other volunteer groups prepared food for the troops. The relatively small village of Stony Brook established the East Farm Canning Kitchen, which sent twenty thousand pounds of jam to France just before the Armistice.[72] They had received some experienced guidance from the Hicksville Canning Kitchen, which carried out the same work in Nassau County.

Although many took—sometimes under social pressure—pledges to support food conservation or put up posters endorsing such measures, such measures were more a matter of building public morale and support for the war effort than actual food conservation.[73] American agriculture was the most productive in the world, and national and international food supplies were largely met by farmers increasing production under the impetus of rising prices and increased demand.[74]

Nevertheless, those who sold or prepared food commercially could find themselves on the wrong side of food conservation policy. Robert F. Weiss, a Freeport grocer, closed his shop for three days, explaining in a sign placed in his window, "We Have Violated the Regulations of the Food Administration, but Have Pledged Full Obedience in the Future."[75]

Although they boasted an abundant number of villages possessing modest, mixed manufacturing, Nassau and Suffolk (and parts of eastern Queens) were heavily agricultural. By the late nineteenth century, under competition from the vast grain belts in the Midwest and Plains states, Long Island farmers had turned to vegetable production, much of it intended for markets in New York City and the surrounding region. While profit was always a factor, farmers were clearly motivated by patriotism as well. The Island's agricultural leadership established the Long Island Food Reserve Battalion, which strove to coordinate and encourage measures increasing production throughout all the Island's four counties. As the state's largest agricultural county, Suffolk was key and often took the lead in pushing for greater production. Not surprisingly, farmers expanded their acreage of the easily grown and stored potato, a staple in both the civilian and military diet. Crop yields from another American agricultural staple, corn, were also increased.[76]

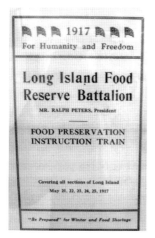

Long Island Food Reserve Battalion Notice of a Demonstration Train. *Private collection.*

The New York State Agricultural School at Farmingdale (now Farmingdale State College) was deeply involved in the efforts to increase crop output in Nassau and Suffolk. Farmingdale director A.A. Johnson oversaw providing adequate seed and fertilizer for the farms. He also assigned the Long Island Food Battalion the task of procuring and distributing seed, as well as securing tractors and fertilizer.[77] The Farmingdale officials found that "stable" manure had become difficult to obtain, as many horses had been taken into service by the army.

A major concern for both agricultural administrators and farmers was farm labor. With so many young men gone off into the armed forces, the available pool of labor had shrunk enormously. Those who remained were often in exempted classes due to war work or age. Long Island farmers often sought draft exemptions for their sons and other "expert" farmworkers, arguing that it was "as highly necessary to raise food as to send men to the front." In general, such requests were denied.[78]

A partial solution, at least, to the farm labor problem came from adolescent boys, high schoolers from both Long Island and the city, who were recruited to work and board with individual farmers, although some were grouped in camps set aside for the purpose. The primary agency for procuring and assigning the young workers was the New York's Boys Working Reserve, a subsection of the State Food Commission. Its Long Island branch was headed by A.L. Crossley, who worked out of Hicksville. It coordinated closely with both the State Farm Bureau and State Education Departments. Indeed, to maximize the utilization of the young workers, New York State ended the school year in May 1918 and did not begin the fall semester until the following November.[79] The New York City Board of Education even prepared to send teacher supervisors to monitor the use of city students on Long Island farms.

The use of teenage labor in the 1917 growing season was deemed a success. The *Long-Islander* stated that many boys were "excellent learners… and proved to be a very efficient aid in the farming operations."[80] "Of course," the paper observed later, "they are boys, and like a horse, they must be properly harnessed, hitched and driven. But if properly managed, they can accomplish remarkable results."[81]

The teenagers, high schoolers or Boy Scouts, volunteered out of patriotism, responding to the blandishments to lend their hand in the war effort. They were paid two to three dollars a day, with an additional stipend of four and a half dollars for board, presumably if they were quartered in private households rather than the camps. There were at least twelve camps for boys in Nassau and Suffolk, and local farmers sometimes agitated for camps to be established in locales convenient to their needs.[82] Press reports mention specific boys' camps at Hicksville and Plainview in Nassau County, as well as Farmingdale, Eastport, Riverhead, Peconic and Sound Avenue (North Fork) in Suffolk.[83]

A special push for young volunteers began to be made in late summer 1918, as the second harvest of the war approached, and A.L. Crossley sent out a call for boys to help bring in the East End potato crop. More than one hundred boys were brought out from city high schools, while each Long Island high school was asked to supply a quota of five or more appropriate students. The boys might "get a few back aches," an editorialist opined, "but nothing in comparison to the sacrifices and sufferings, of the boys in France."[84] The crops were brought in, food production soared—perhaps too much for the farmers, as their profits fell—and the nation supplied itself, its armies and its Allies with abundant sustenance.[85] When the war ended in November, the experiment of boy labor, in some ways a prototype of the New Deal's Civilian Conservation Corps, ended as well.

One source of farm labor was rejected: young women. Although newspapers reported that young women from local schools and colleges participated in farm and garden work during the 1917 season, the prevailing attitude among the Island's agricultural establishment was that farm work was men's work.[86] In early 1918, the Suffolk Farm Bureau reported that it was receiving inquiries from girls and young woman about the possibility of agricultural labor. The bureau publicly responded that they should seek household employment. "The heavy work on the farm must be done by men, who have the physical strength for it," they explained. "For that these men must be fed, and that there is a great chance for women who can cook to cooperate in the general advance of agriculture and food production by taking this particular line of activity."[87]

Women may have been generally excluded from commercial agriculture, but their labor was a significant element in war industries, fundraising, the Red Cross and Salvation Army, which provided health, medical and recreational services to the troops both at home and in France. Additionally, twelve thousand army nurses tended to the sick and wounded. U.S. Army

telephone communications in France would have been impossible without the substantial number of "Hello Girls" who ran the system. There were also smaller numbers of women in the women's branches of the armed services.

The mobilization and participation of women in the war effort spurred on the cause of women's suffrage, which had been gathering steam since the last quarter of the previous century. By 1917, eleven states had already extended the franchise to women, although some continued to resist the reform. Consequently, agitation for a women's suffrage amendment on the federal level intensified. With the outbreak of the war, the two major suffragist organizations split over tactics. Carrie Chapman Catt's National American Woman Suffrage Association somewhat reluctantly threw its support to the war effort and generally ceased suffrage agitation for the course of the war.

In contrast, Alice Paul's National Woman's Party argued that suffrage couldn't wait. Beginning on November 11, 1917, Paul and some of her more militant colleagues began picketing the White House daily, Sundays excepted. They sought to embarrass the administration, which boldly claimed to be waging the war for democracy while denying the system's most essential element to half its population. Protesting suffragists found themselves abused and sometimes arrested by the police and counterdemonstrators, actions that garnered sympathetic press and consequently put even greater pressure on Wilson to intervene.

By late November 1917, some sort of an understanding was reached between the administration and the National Woman's Party. Paul, who was in jail, was released and called off the picketing and demonstrations. In response, the administration publicly called for the passage of the women's suffrage amendment, citing women's contributions to the war effort as conclusive evidence that they had earned the rights of full citizenship.

Published opinion on Long Island embraced women's suffrage wholeheartedly. Papers printed Wilson's call for voters to approve the amendment. The *Long-Islander* spoke for the majority in an editorial that appeared even before the Wilson-Paul agreement:

> *The women of this country have shown such a splendid spirit of patriotic devotion to the welfare of the nation in this great crisis and have rallied so nobly to the support of the government that men heretofore opposed to the granting of suffrage to women have come to see the wisdom and expediency of the enlargement of the electoral franchise. In all those qualities that go to make up a desirable citizenship, millions of American women, have shown themselves pre-eminent. This war has emphasized the fact that women are*

THE PLATTSBURGER

AS A WAR MEASURE

The Country is Asking of Women Service	Women Are Asking of the Country
AS FARMERS MECHANICS NURSES and DOCTORS MUNITION WORKERS MINE WORKERS YEOMEN GAS MAKERS BELL BOYS MESSENGERS CONDUCTORS MOTORMEN ARMY COOKS TELEGRAPHERS AMBULANCE DRIVERS ADVISORS TO THE COUNCIL OF NATIONAL DEFENSE AND	**ENFRANCHISEMENT**
The Country is Getting it!	Are The Women Going To Get It?

Vote for Woman Suffrage Nov. 6

Support for the women's suffrage amendment in the Plattsburgh Camp magazine, 1918.
Courtesy of the Longwood Public Library's Thomas R. Bayles Local History Room.

just as patriotic, filled with as high ideals, understand the vital political issues of the day and the country's needs, and are making just as great sacrifices as the men for the welfare of the nation.[88]

Above all, Long Islanders, like most Americans, sought to avoid any behavior that could lead to their being labeled a "slacker." A slacker was anyone who failed to do his or her part in the war effort. A slacker might fail to display a food conservation pledge, refuse to participate in Liberty Loan drives, evince reservations about the draft or America's Allies or, worst of all, fail to register for the draft or desert the military. Slackers were the main target of the American Protective League, a government-endorsed volunteer organization that intimidated those who seemed under-enthusiastic about the war effort and endeavored to coerce loyalty when necessary.

While the American Protective League doesn't seem to have operated on Long Island, it was very active in New York City during the summer of 1918, when it played a key role in "Slacker Raids." The largest of these occurred September 3–5, when as many as twenty thousand members of the League joined police and Justice Department agents in blocking entrances to subways, ferries, trains, theaters, saloons and restaurants. Sixty-seven thousand men were detained on suspicion of draft dodging. Most of the men held simply couldn't document their draft status; 199 actual draft dodgers were discovered, along with possibly 8 deserters. The remainder were shortly released.[89]

The activities of the American Protective League, an ambiguous mixture of governmental and social intimidation, evoked surprisingly little public resistance, primarily because few wished to be seen questioning efforts to support the war. The September "Slacker Raids" marked the high point of the League's influence. The government began to withdraw its support, and the outbreak of the Spanish influenza epidemic, soon followed by the Armistice, combined to end the league's brief, if troubling, activities.

The anti-slacker message was reinforced through motion pictures, which required approval of the Committee on Public Information, the federal propaganda ministry led by George Creel. In the fall of 1917, Huntington residents were invited to view *The Slacker* at the Knights of Columbus Hall. Shown under the auspices of the Red Cross, newspaper ads explained, "This is no war picture. A big patriotic feature without a battle scene. The most amazing production of a generation."[90]

In the words of George Creel, the Committee on Public Information's mission was to turn the American people into "one white-hot mass…a

fraternity of devotion, courage and deathless determination."[91] Dissent was punishable by law under the Espionage and Sedition Acts and, in some parts of the country, extra-legally through vigilantism. On Long Island, those who questioned or opposed the war seem to have fallen into silence.

Chapter 4

ALL IN

Every day appears to be 'Flag Day,'" the *County Review* crowed in April 1917, and indeed, displays of national colors erupted across the Island and nation. On April 29, a "Grand Patriotic Rally" was held at Greenport on the North Fork; 1,200 people showed up at the Metro Theater, where the festivities were scheduled, a number so large that many could not get in. The aging Civil War veterans of the Grand Army of the Republic led a procession to the theater, and 175 men representing Home Guard units from Greenport, Mattituck and Shelter Island lent a more contemporary military air. The audience was treated to speeches and exhortations from local politicos and ministers from various denominations, and the event finished with the passage of a resolution in support of the president.[92]

Even June 5, 1917, the day selected for men between twenty-one and thirty-five to register for the draft, was ready made for public demonstrations of commitment to the national crusade. It "was not a day of festivities in Freeport," Nassau's *County Review* declared, "but rather a day of patriotic inspiration to our citizens, young and old."[93] The polling places designated as draft registration centers were open from 7:00 a.m. to 9:00 p.m. Members of the Women's Relief Corps manned the polls and pinned special ribbons on each of the registrees. Although "there was no trouble during the day [and] none was expected," the presence of the Sheriff's Reserve suggests that authorities were initially unsure that would be the case.

Freeport also organized an afternoon parade intended to allow the citizens to "express their patriotism in a public manner."[94] The parade was led by

officials on horseback, followed by the village trustees. The elderly members of the GAR rode in automobiles. They were followed by the Sherriff's Reserve, Red Cross, fire departments, fraternal lodges, the Boy Scouts and "about a thousand school children."

It was clear that the Red Cross would be heavily engaged in troop support, playing a key role in operating military hospitals, as well as administering food and clothing relief in Europe and the nation. Morgan banker and Lattingtown resident Henry Davison, who had arranged massive loans to the Allies before the war, assumed the position of chairman of the Red Cross War Council at a salary of $1 per year.[95] By the war's end, 19 million adults—8 million active volunteers and 11 million youths—had joined the organization, allowing it to raise more than $400 million.[96] Twenty thousand registered nurses were enrolled in the Red Cross, providing much-needed expertise in critical medical areas.[97]

Meanwhile, Davison's wife, Kate Trubee Davison, helped organize and became treasurer of the War Work Council of the National Board of the Young Women's Christian Association (YWCA), which provided rooming, recreational activities and "safeguarding" for the thousands of young women arriving at military bases and factories volunteering for war-related work.

Red Cross rallies and fundraisers occurred regularly in many villages of Long Island throughout the conflict. Huntington established its own local chapter on May 7, 1917. The village already had a Belgian Relief Fund, and some had raised money to support French hospitals. The local press believed that the new chapter would be primarily involved in supporting hospitals. Red Cross activities, the local newspaper emotionally declared, would help bind the United States "in the closest possible love and affection to France and Great Britain and strengthen our hold on the good will of all the other nations of the…allied powers.…[I]t would be a most valuable contribution to the success of the Allied armies in the field. This is a matter of utmost importance in this great war for the very existence of liberty and popular government throughout the world."[98] The genuine contributions of the Red Cross aside, in 1917 what the western Allies wanted most were American troops, ships and military supplies.[99]

Leading Huntington village support for the "Red Cross Week" money-raising campaign, the Ketewamoke Chapter of the Daughters of the American Revolution arranged a "Win the War" pageant at the Palace Theater on New York Avenue just south of Main Street. Speakers from the national Red Cross addressed the crowd, stoking support and contributions.[100] The charity had assigned Nassau and Suffolk Counties a quota of $300,000 and

was no doubt gratified when the counties' efforts had raised $541,000 by the end of the month.[101]

Occasionally, a company would sponsor a revenue-raising event. In August 1918, the Bliss Torpedo Company lent its property to the Women's Naval Service Inc., a support group, as the site of a Red Cross ball. A military band from Camp Upton joined the popular Canoe Place Inn Orchestra in providing dance music for the participants. Diving and swimming demonstrations by Miss Annie Kellerman were a bonus attraction.[102]

The Red Cross had no monopoly on rallies and fundraisers, and many public events were aimed not so much at raising money as ramping up public morale and fervor for the war. Such was the impetus behind Riverhead's "Big Mass Meeting" in April 1918. This event was the brainchild of the National Committee on Churches and the Moral Aims of the War, an arm of the Committee on Public Information, the federal government's propaganda agency. Promotional hype produced a larger turnout than anticipated, with attendees overflowing the designated auditorium, forcing the organizers to press the First Congregational Church into service as a satellite facility. Churchmen and a correspondent from the *London Daily News* addressed the crowd, while bands and choirs performed, patriotic songs being favored.[103]

Unsurprisingly, Independence Day witnessed many of the most spectacular manifestations of wartime fervor. Huntington's July 4, 1918 celebrations drew 1,500 spectators and participants. Most patriotic celebrations featured a parade, and the Huntington event was no exception. The grand marshal was followed by Miss Olive Scudder, who was outfitted as Columbia. Behind her trooped several standard-bearers carrying the flags of the Allied nations. New York Guards, Home Guards, the GAR, fire departments and sundry civic groups all trooped the colors in a public demonstration of support for the boys in camp or at the front. Such commemorations were irresistible to politicians seeking opportunities for bloviation, although the public also expected it of them. Speaking to his gathered constituents, the town supervisor emphasized patriotic heritage and called for the foreign born to become Americanized—"no hyphenated citizen should be tolerated."[104]

Almost any event could become a vehicle for fanning patriotic enthusiasm among the citizenry. In July 1917, the area in and around Huntington village was selected by the Vitagraph Film Company as a stand-in for the Western Front in a movie titled *For France*. Occurring just as the lists of the first draftees were published, the film generated great public interest. Vitagraph press releases promised "[a]ctual battle conditions, with infantry and Artillery Action,

Long Island and World War I

Cecile Rogers representing Liberty in Stony Brook's Liberty Day Parade, October 1918. *Courtesy of the Three Village Historical Society.*

Cavalry Charges, Trench fighting and Air Plane scouting are Produced with almost scientific accuracy in 'For France.'"[105]

Nor was that all. With the cooperation of state and federal authorities, 1,500 regulars and national guardsmen were provided for the feature. E.F. Roosevelt, Theodore's cousin "recently returned from France," lent his expertise as a technical advisor. Reportedly, officers from Forts Hamilton and Totten intended to use the filming as a training exercise for soldiers off to the Western Front. Guards were posted around the areas where the movie was filmed since, per the press, "real ammunition was used and automobiles were in constant danger of stray bullets. Not a causality was reported, however."[106]

No doubt those who got to watch the filming felt they were receiving a glimpse into the realities of the war raging in Europe and, presumably, a greater understanding of what their young men would be facing in Europe. In any event, the filming was quick, and those who never got near the filming sites could see the finished work at their local theater later in the week.[107]

Among the largest wartime rallies were those connected with Liberty Loan drives. The massive expenditures required to increase the size and capabilities of the American military, not to mention the huge amount of aid to the country's allies, necessitated the creation of new sources of revenue for the federal government. Since it was impossible to fund the war entirely through taxation, the United States joined all the belligerents in turning to its citizens for support. The wartime loans were dubbed "Liberty

Loans" to emphasize the nation's stated aim of fighting the war to overthrow totalitarianism and militarism and "making the world safe for democracy"—or, in the words of Woodrow Wilson, the Liberty Loan "is to be a loan from a free people to be used in freeing the world."[108]

Four Liberty Loans were floated during hostilities, with a fifth projected for 1919. When the war ended in November 1918, the latter was repackaged as the Fifth "Victory Loan," with the stated goal of helping bring the boys home from France. Generally, the loans were purchased by banks, which then marketed them to the public. Usually, one or two of the larger banks in towns handled the loans. Bond quotas were assigned to the states, which then subdivided the requisite total among its counties and towns. Many were sold, but the overall targets were not always reached.

Boy Scouts and Campfire Girls were commonly enlisted to canvass local neighborhoods for subscriptions and pledges.[109] Likewise, prominent citizens joined politicians and religious and civic leaders in exhorting the populace to subscribe to the loans. Liberty Loan drives were ordinarily inaugurated by elaborate rallies, like those held on the Fourth of July, Labor Day and other major holidays. A Liberty Loan rally held in Huntington in the fall of 1917 led off with a parade and gathering in front of the Bank of Huntington, which handled a large part of the village's loan sales. A typical mix of politicians, GAR, the Liberty Loan Committee, Sons of the Revolution, Home Guards, fraternal lodges, fire departments and the ever-present Boy

Receipt for a Liberty Loan donation, Huntington. *Private collection.*

Scouts formed up to show support. The assembled organizations then marched through the village amid flags, decorations and enthusiastic supporters.[110]

Some village Liberty Loan drives featured patriotic or anti-German symbols to drum up support. For the Third Liberty Loan, Far Rockaway on the South Shore constructed an effigy of the Kaiser and pushed him toward the ocean at the rate of one push per every several thousand dollars in bond sales. The village of Flushing in Queens County fashioned a large mannequin of Uncle Sam painted in red, white and blue. He was pushed down Main Street toward his goal at the rate of two and a half feet per every $1,500 in subscriptions. Papers happily reported, "He is travelling at a fast clip, in fact he is almost running."[111]

Perhaps because of its status of being in one of Suffolk County's most prominent war industries, the Bliss Torpedo Company organized its own Liberty Loan rally at Sag Harbor in June 1918. The event kicked off with an "elaborate dinner" at the head of the village's Long Wharf. The company's president, J.W. Lane, promised a fifty-dollar bond to every employee who subscribed to the Third Liberty Loan and who worked through the fiscal year. Accompanying Lane was a British army officer who delivered a "stirring" address. The evening concluded with the lighting of a huge bonfire into which an effigy of the Kaiser was lowered and burned.[112]

Local celebrities were included in the various wartime rallies wherever possible. Film star Edith Story, who kept a summer home in Asharokan, joined Northport village's Fourth Liberty Loan festivities. Speaking before the screening of her latest flick at the cinema, she made a personal pledge of $1,000, which helped inspire contributions from the audience reaching $9,150.[113]

The government's "Thrift Savings Stamps" were marketed toward people with little money. When the stamp booklet was full, it could be exchanged for a low-denomination interest-bearing War Savings Stamp. *Author's collection.*

Partially completed "Thrift Savings Stamp" booklet. *Author's collection.*

Officially, the Wilson administration distinguished between the German people and its government, with the United States fighting to effect what later became called "regime change." Shortly after the declaration of war, editorialists in the *Long-Islander* asserted, "It is not against the common people of Germany and Austria that this war is being raged.…This conflict is being waged against a hierarchy which has created a vast and powerful military machine…making tremendous efforts to control the political and industrial affairs of the whole world."[114]

In practice, the separation between the German government and its people was blurred. Much of the propaganda released by George Creel's Committee on Public Information depicted all Germans, from the emperor to the drafted foot soldier, as "the Terrible Hun," a reference toward a barbarian group that savaged Europe in the sixth century. Playing to the emotions and assumptions of their audience, speakers at wartime rallies aroused anti-German animus with their descriptions, not always accurate, of the sufferings of Belgian and French citizens under the heel of "the Hun." Others derided German "kultur" in general.

Such themes became a common element at the wartime rallies. Speakers emphasized the moral and legal justifications for the war, the rectitude of the Allied side and villainy and inhumanity of the Central Powers—again, most especially Germany. Kaiser Wilhelm II, whose love of military display and bellicose outbursts before the war were well remembered, provided a perfect symbol of presumed German totalitarianism and militarism. He became the main target of much anti-German propaganda emanating from both the government and popular sources. The relatively new medium of motion pictures, which was proving a powerful propaganda tool, took up the campaign with zest. Titles spewing from the movie companies included *The Kaiser or the Beast of Berlin*, *To Hell with the Kaiser* ("Bigger and better than *Four Years in Germany*") or, more ominously, *The Hun Within*.

Anti-German propaganda. This image appeared repeatedly during the war. *Courtesy of the New York Public Library.*

With some frequency, bond, Red Cross or holiday rallies featured Allied officers who described the sacrifices of their nations, the lethality of modern industrialized combat and the brutality of their adversaries. As American troops began to see action, some returned due to wounds or furloughs, and they, too, were pressed into bond and recruitment drives.

Later Liberty Loan drives, especially the Fourth Liberty Loan in October 1918, directly incorporated war matériel and symbols. Ads in local papers promoting the loan included the popular poem "In Flanders Fields." Others borrowed a phrase from trench warfare when a town

or village reportedly met its pledge quota, proclaiming it went "Over the Top."[115] Military hardware and battlefield relics often provided backdrops for loan drives and certainly attracted crowds. The new military technology of tanks and aircraft proved especially popular. The Long Island Railroad lent its services in this regard by providing a "Trophy Train" to drum up enthusiasm for the Fourth Loan.

The "Trophy Train," which stopped at eight selected Long Island stations, carried a selection of captured German equipment accompanied by army veterans who described and explained the artifacts and their uses or significance. Helmets, gas masks, shells, machine guns and hand grenades were housed in baggage cars, while a flatbed car bore captured German cannons.[116] The train, which was greeted by bands, local leaders and the like, remained about two hours at each stop before proceeding. Although officials credited the trains with creating a bump in subscriptions, others believed that the number of visitors would have been larger except for health board warnings against large public meetings in the face of the virulent Spanish flu epidemic. The fact that visitors moved quickly through the train probably stemmed from that reason as well.[117]

The Salvation Army, YMCA and Knights of Columbus were among the organizations providing support and recreation for the men called in to service. A Y "hut"—a cabin with chairs, writing tables and literature and offering light refreshments—was an almost standard feature at military installations in the United States and in France. Similar facilities soon appeared at Long Island's other camps and bases.

Women, especially society women, often took the lead in such support efforts. In the summer of 1917 a committee led by prominent women, including Mrs. W. Emlen Roosevelt and Mrs. Stanford White, organized an Island-wide committee to raise money for "Hostess Houses" for the YMCA at Camp Upton. The "Hostess Houses" were intended to provide "a place for refreshment and rest for wives, mothers, sisters, relatives and friends who come to visit the men in camp."[118] On September 8, 1917, Mrs. J.A. Ferguson of Huntington opened her home, the Monastery (also known as Ferguson's Castle), for a "Hostess House" fundraiser. Officers in uniform were admitted gratis.[119]

Towns and villages also set up recreation rooms or canteens for soldiers on leave or visiting from the several camps on the Island. Riverhead announced its "Soldier's Club" on Main Street in April 1918. Writing tables and billiard tables were planned, and it was hoped that the second and third floors would be used as dormitories for soldiers. Mostly from nearby Camp Upton, troops

who were unable to find accommodations in the local hotels could stay at the Soldier's Club. The planning committee specifically stated that it was "not the intention of the management of the club…to compete in any way with the hotels and boarding houses." Patriotism was not to limit profit.[120]

Huntington's Recreation Room and Canteen was situated in the firehouse. The canteen, operated by the Citizens Committee headed by Mrs. Raymond E. Baylis, housed reading and writing tables, a Victrola and a piano and served light refreshments. Overnight accommodations were available, and cots and mattresses were available at the canteen's annex in the Knights of Columbus Hall.[121]

The village of Northport, closest to Brindley Field, offered the local yacht club's facilities to soldiers in the warm months and provided facilities for visiting troops at the Masonic Hall during winter.[122] Patchogue, on the South Shore, established a Military Club for visiting servicemen, and the Jewish War Board soon followed suit. Freeport, in Nassau County, established a War Camp Community Service Club, providing reading and writing materials, dances, entertainment and meals, mostly for the men stationed at Camp Mills or Lufbery Field, the two closest military posts. Village authorities estimated that its WCCS center provided services and recreation for 200,000 men throughout the war and during the demobilization period.[123] Even small villages such as Center Moriches and Eastport set up canteens providing snacks and small meals for the doughboys.[124]

Some officials, both military and civilian, were intent on setting the proper moral and social tone in the recreation centers. They were often troubled about the character of the personnel or visitors with whom the young trainees would come into contact. William C. Newton, a secretary for the Nassau-Suffolk YMCA, which was deeply involved in providing support facilities for troops both on and off base, investigated the establishment of canteens in Long Island's villages. "The soda water fountain type of girl should be eliminated," he concluded, apparently fearful of the young men meeting flirtatious young women. He was also worried about the character of those transporting soldiers to and from camps and villages. Some taxi men, he warned, made money "furnishing liquor to soldiers, and other illegal practices." Clearly, they would need to be monitored closely.[125]

Long Islanders expressed their support for the nation, government and military in manifold ways. Aside from the servicemen themselves, who made the greatest sacrifice, large numbers joined the Red Cross, Salvation Army and armed service support leagues or manned the "huts" provided for the soldiers' leisure and recreation on the Island's military installations.

Many helped organize the recreation rooms for the troops in the different villages, especially those within ready access to the camps. Some even took individual soldiers into their homes for dinners and overnight stays. Others contributed to the war loans or the organizations serving the troops, helped throw dances for the young men or hosted and participated in patriotic celebrations. Still others gave encouragement by writing to the men in service, especially overseas. And more demonstrated their support just by showing up at the many events designed to demonstrate their loyalty, commitment and patriotism.

Chapter 5

SUSPICIONS, APPREHENSIONS AND FEARS

The upsurge of patriotic fervor released by the American entry into the Great War was coupled with wariness and suspicion toward those who seemed to lack necessary prowar enthusiasm—or, even worse, might endeavor to impede, thwart or even sabotage America's wartime crusade. Immediate fears centered on possible German sabotage, such as the spectacular Black Tom explosion in 1916. Such concerns were not unjustified, as German agents had plotted similar operations that had been detected and upended by the government. Perhaps because of greater security and vigilance, no significant incidents of sabotage occurred after war was declared. Worries about possible German invasion were quickly exposed as hysterical fantasies, although German U-boats did operate off the American coast.

Even before the nation officially entered the conflict, President Wilson was fearful that resistance from the German American community might be large enough to trigger a civil war. His closest advisor and confidant, Edward House, did "not look for any organized revolution outbreak," but he did foresee possible "attempts…to blow up water works, electric lights and gas plants, subways and bridges in cities like New York."[126] German sabotage that actually occurred, in 1915–17, was the work of German agents in the country, not German Americans, and Wilson's fears proved groundless. Although many German Americans had supported or given aid to Germany throughout America's neutral period, they overwhelmingly supported the American cause once war was declared.

Nevertheless, the war with Germany unleashed a torrent of anti-German feeling that extended to the large German American population in the country. The Espionage Act of 1917 conferred broad powers on the government to suppress speech, writing or actions "with intent to interfere with the operational success of the military or naval forces of the United States or support its enemies." The Sedition Act of 1918 expanded punishments for "disloyal, profane, scurrilous or abusive language" directed at the war effort, vague categories that could embrace anything. Enemy aliens, German immigrants and non-naturalized residents were registered with the authorities. Ellis Island became a detention center for many such people. Following the Bolshevik Revolution in November 1917, increasing numbers of non-German radical immigrants, mostly of the leftist variety, made up most detainees (as did deportees after the war).[127]

Language and culture became flashpoints. Although Wilson decried vigilantism and called for friendly treatment of loyal German Americans, attacks on German American cultural and fraternal organizations forced many to suspend operation. German language instruction was suspended in many school districts, and German composers were banished from the repertoires of orchestras. Public burnings of German-language books were carried out in several cities, a stein-breaking ceremony sponsored by the Red Cross occurred in Omaha and citizens of Columbus, Ohio, announced a meeting to kill German dog breeds.[128] Most did not go that far and contented themselves with renaming German shepherds "police dogs" or "Alsatian" shepherds. Nevertheless, there were some instances of beatings and tarring and feathering of German Americans considered insufficiently patriotic. One German American was lynched. The purge of German influences in American life extended to food. Sauerkraut was rebranded "liberty cabbage" and hamburgers "Salisbury steak."

The more extreme forms of anti-German hysteria were not much in evidence on Long Island, although instances of intimidation and social coercion appeared. A small hamlet near Islip named Germantown changed its name to Islip Terrace to avoid any suggestion of contamination with treason because of its name.[129] In Amityville, the local board of education declared its intention to drop German language instruction. Students who had begun studying German could continue, but no new students would be enrolled. The matter was referred to the state education department, whose approval was necessary for the prohibition to be implemented.[130] Farther east in Patchogue, newspaper vendors mutually agreed to cease selling German-language newspapers.[131]

Politically incorrect color combinations could lead to public reprimand. An Amityville barber was told to change the colors on his pole from red, white and black, the colors of the imperial German flag, to red, white and blue. When he protested that he had used black because the blue paint faded, he was told that if he didn't remove the pole or repaint it, somebody else would. He complied.[132]

Across the United States, German American civic, social and cultural organizations curtailed activities, adopted low profiles or dissolved themselves under the storm of anti-German sentiment unleashed by the nation's entry into the war. Community suspicions of German Americans led Amityville's German-American Alliance to disband in March 1918. The social group announced its dissolution with a public resolution stating that the "national unity of all our people is of the utmost necessity for the country's victory in the present war."[133] Following the mandatory professions of support for the war, the organization went on to address the real cause of its demise: the growing hostility of their fellow-citizens. "[I]n order to ease the minds of those of our neighbors who have questioned the purposes and loyalty of this organization, and who, by senseless passion and prejudice seek to bring on this organization an undeserved humiliation, it is resolved that we dissolve the German-American Alliance of Amityville, patriotic though it has been, and in no wise to blame for the existing feeling, and that we hope for a continuance of the old-time feeling of a common Americanism among our people."[134] Some of that "old-time feeling" would return, but not in 1918.

At almost the same time, a local branch of the Friends of Germany met at Farmingdale. The group was a government-approved organization composed of German Americans who urged their relatives in Europe to "rid themselves of their military autocracy and establish a government with which the Allies can make peace."[135] Clearly intended to provide an acceptable means for Americans of German descent to express their support for the war, the Friends sought to "align all Americans of German source squarely behind the great principles promulgated by President Wilson as American war aims."[136] How many Long Islanders of German heritage joined the Friends is unknown, but the organization provided a ready tool for those who felt the need to prove that their ancestry did not taint their identity as Americans.

Public criticism of the war effort or administration could result in unhappy consequences. Shortly after the American entry into the war, Hal B. Fullerton, special agent and photographer for the Long Island Railroad, overheard Leonard B. Pomeroy say that the "United States is not worth

a damn."[137] Fullerton quickly contacted the sheriff, who hauled Pomeroy before the justice of the peace. Pomeroy claimed that he wasn't serious and meant only that the country was not prepared for war. The justice, George W. Hildreth, gave Pomeroy "a good patriotic lecture," before releasing him with a suspended sentence, while also forwarding his name and address to the Secret Service.[138]

The following January, the librarian at the Sag Harbor Library claimed that an unknown German man asked to take German-language newspapers from the building. When told that they could not be removed, he called her a "damned Yankee." The librarian, Miss Dutcher, replied that she was "an American and proud of it." The *Sag Harbor Express* commented that it was too bad the German was unidentified, as he would otherwise be made known to "the local committee headed by G.A. Kiernan which is made up of some of our representative citizens whose duty is to have pro-Germans attended to in a befitting manner for our times."[139]

Spy scare was another form of war hysteria, especially in the opening months. William Christianson, supposedly a member of the German air service, was arrested on July 27, 1917, in Huntington after asking questions about the "hydroplane base on the edge of Huntington Bay"—the Yale Naval Reserve Unit.[140] A man acting suspiciously in Huntington Harbor was seized for allegedly making drawings, which he hid when approached. He was released after a court hearing in which he was deemed only a "pleasure seeker."[141] Well-known philanthropist August Hecksher felt compelled to sue two Huntington women for slander. One said that no citizen of German birth, as Hecksher was, could be a loyal American and went on to say that Hecksher was pro-German and probably violating the Espionage Act when he was out in his boat in Huntington Harbor.[142]

Language and culture also became flashpoints in defining who was a patriotic American and who was not. The *Long-Islander* argued that the war had made it "more necessary than ever before that everyone living in the land today should know how to speak and read the common language of the country."[143] A short time later, the paper insisted that laws were necessary to prohibit those who could not read or write English from voting in federal elections. "Aliens should pass an examination showing their ability to read and write simple English sentences, and no immigrant should be allowed to remain in the country more than three years" who could not demonstrate that ability.[144]

The language issue was part of the concern for the Americanization of the country's large immigrant population, a concern fanned by the war. As

the *Long-Islander* put it, "It is a matter of good public policy to amalgamate all the foreign elements in the country as rapidly as possible into a homogenous whole and that whole to be thoroughly and loyally American, a general knowledge of the language is one of the most effective means toward the accomplishment of that end."[145] Such concerns would factor heavily in the decision to greatly reduce immigration from the 1920s to 1965.

How Americans themselves used their language also became an issue of concern in some quarters, especially regarding ethnic sensibility. Social and governmental leaders concluded that the common use of derisive slang impeded the process of Americanization. Believing that the best starting point was with the young, an unnamed "United States commissioner" asked the Boy Scouts to discourage the use of "nicknames" for members of Allied countries. But the policy extended beyond references to members of friendly nations and Allies. The suppression of ethnic slang was also seen as a means of building a homogenized American identity. Consequently, the Boy Scouts were encouraged to adopt a "Code of Honorable Names," with the goal of bestowing the "honorable name of 'American'" on all citizens.[146] The suggested Boy Scout "Code of Honorable Names" pledged the Scouts to eschew the use of "Dago, Dutchy, Froggy, Ginny, Greaser, Hainy, Hirwat, Hunky, Kike, Mick, Paddy, Sheeny, Spaghetti, Wop, as applied to any foreign-born resident of the United States of America." Only ethno-religious slurs appeared on the list of proscribed terms. Racial epithets did not make an appearance.[147] How the pledge went down with the Boy Scouts is unknown.

Despite fears of widespread disloyalty among the German American population, most Americans of German birth, parentage or descent responded as most other Americans did. The *Long-Islander*, acutely sensitive to ethno-cultural concerns, went out of its way to applaud the performance of German American soldiers. "There are no more loyal or efficient fighting men in our ranks than the German-American from Wisconsin and Michigan, and the Great Northwest," its editorialists enthused, citing states with heavy German populations but strangely ignoring German communities much closer to home, such as Steinway, Yorkville and Ridgewood. These men were "fighting side by side with the native Americans [meaning native-born or of British descent] from the plantations of North Carolina and Georgia or the green hills of Vermont."[148]

Moreover, the presence of so many German Americans in the army allegedly came as "quite a shock" to many German troops. Reports claimed that "a number of German PWs said that if they were brought for internment in America they would never go back, but, instead, send for

their wives and children to settle here."[149] "This is a consideration much to be desired," the paper observed, reflecting on the benefits of stereotypical German virtues shorn of militarism and Kaiserism. "They will bring with them habits of industry, thrift, honesty, and intelligence that will prove an asset. No danger but that they will in years to come prove to be loyal citizens."[150] That assumption was never put to the test, as no Germans were ever sent to the United States as prisoners of war.

The demands of the wartime economy, domestic and international, resulted in price rises, some shortages and concerns about corporate profiteering. Charges that certain manufacturers, wholesalers and financiers were lining their pickets at a time of national crisis appeared in the press and among the public. The *Long-Islander* predicted that "the Administration can and will put an end to the almost universal craze on the part of the manufacturer, the speculator, and the retailer for profiteering that has manifested itself since the beginning of the war. Men and women with a small salary and wage earners by the millions have been the helpless victims of this craze, and suffered the pangs of hunger and cold."[151] Continuing in a manner that reflected the strong socialist strain in the Progressivism of the times, the paper stated, "It is merely a question as to whether a Government representing the entire nation shall control these matters or a group of greedy capitalists with their wealth [are] able to monopolize the entire output of the country…without any check in their greed and with responsibility to no one but themselves." "The old laws of supply and demand," the editorialist declared flatly, "have become anachronisms."[152]

Indeed, production bottlenecks, price gouging, inflation and the need for greater production efficiency led the Wilson administration to institute several measures designed to centralize and maximize the nation's war efforts. The U.S. Food Administration, led by Herbert Hoover, encouraged both production and conservation; the Railway Administration nationalized the railroad networks during the war; and the War Industries Board administered essential industries, allocated vital materials and set aside anti-monopoly laws in the name of speed, efficiency and output. While these measures dramatically stoked the country's enormous industrial potential, complaints about war profiteering and price gouging appeared with some regularity.[153] Industrialists and corporate leaders controlled most of the government boards, and although they did indeed deliver the goods the country needed, most businesses thrived under the war socialism. In any event, all the government-operated boards were allowed to lapse after the Armistice.[154]

While many Americans denounced strikes in critical industries as treasonous, the overall concern regarding labor were the activities of the radical Industrial Workers of the World and its sympathizers.[155] The IWW, or "Wobblies," sought the overthrow of the free-market system, to be replaced with a communist economic-political system. Moreover, it refused to renounce violence, and its members were implicated in bitter labor confrontations. Denounced by the American Federation of Labor, it was also opposed by business interests threatened by its agenda, especially after the Wobblies won several strikes in western mining camps. Their refusal to suspend organizing campaigns and strikes, along with their general refusal to support the war, led different levels of law enforcement to move against them. Such efforts were generally cheered on by skilled workers and the middle class, as well as business owners.

Although it tended to support what was effectively war socialism—albeit controlled by government-business alliances—Huntington's *Long-Islander* took a hard line against radical labor, "Wobblies" or otherwise. The vehemence of its denunciations was fanned by fears that the radicals were undercutting the war effort through strikes and agitation.[156] "The government should carry out the most radical policy necessary for their suppression. It would be a good thing for the country if they could be banished to some island where they could work out their theories on each other to their heart's content. Even the rattlesnakes would try hard to get away from such a colony."[157]

"They are traitors to their country, constantly plotting treason," the paper continued, "and there is abundant evidence that their organization has been in the pay of the German Government." The foreign connection, for which there was little or no evidence, was repeated one month later. Referring to labor shutdowns in general, the *Long-Islander* denounced them as the work of "German and Fenian [Irish republican revolutionaries] sympathizers."[158]

Subject to government investigation and prosecution, the "Wobblies" were in disarray by 1918. When one hundred of its members were convicted under the Sedition Act for rendering aid to the enemy, the *Long-Islander* rejoiced, hoping that the sentences would be so severe that "these pestilential and dangerous fellows will be cowed into submission everywhere."[159] The editorialist also commented favorably on reports that Oklahoma farmers had seized and whipped IWW organizers in their neighborhoods.[160] They got their wish. Between wartime harassment and suppression, plus the anti-radical wave that swept the nation in the aftermath of the war, the Industrial Workers of the World was all but extinct as the new decade dawned. Other

labor organizations (often militant but less extreme) would carry out the campaign for labor rights and union recognition.

The arrival of thousands of young men at Long Island bases and training camps aroused both patriotic pride and concerns about their behavior and effect on the Island's residents and mores. Construction at Camp Upton was barely underway when reports appeared charging some soldiers with "causing considerable disturbance in Patchogue."[161] In October, an African American soldier of the all-black 15th New York National Guard unit (later the U.S. 369th Regiment), which was assigned to guard duty at Upton, was sentenced to not less than two years, six months for stabbing a sergeant of the same unit at a "colored ball in the Lyceum Theatre" at Riverhead. The sentencing judge laid a lot of blame on the "rum hole that sold this liquor on this night [and] put you here."[162]

Indeed, the military had banned all liquor-serving hotels and saloons within a five-mile radius of Camp Upton, and under the terms of the Selective Service Act, citizens were prohibited from selling or providing alcohol to soldiers even in private homes.[163] This did not mean the men didn't try to get it. On December 17, 1917, authorities raided the White Oak Inn at Medford and arrested "the comely proprietress," Mrs. Lucy Asking, on the charge of selling liquor to soldiers. She was sentenced to thirty days in jail.[164]

The outbreak of the war intensified the campaign against prostitution that had been building for several decades. Although the army had tolerated, and sometimes regulated, prostitution near its camps in the past, official policy changed, and military officers joined reformers in a campaign to shut down brothels near military installations. Concerns about soldiers' drunkenness was now coupled with fears of widespread venereal diseases, reducing troop strength and undermining effectiveness, not to mention sapping young American men's moral fiber. The Storyville district of New Orleans, a notorious red-light district that played a significant role in the development and dissemination of jazz music, was among those shut down by military authorities at the time. While there were no neighborhoods on Long Island devoted to vice, concern about prostitution and extramarital sex were heightened by the presence of so many young men in uniform. Sometimes, concerns led to fabrication.

In December 1917, the Committee of Fourteen, a self-selected anti-vice group headquartered in New York City, dispatched a special investigator, Harry B. Sussman, to pursue evidence of illegal sex in the villages near Camp Upton. He brought charges of "white slavery" against Sylvester Swezey.

Following a brief trial, Swezey was acquitted after it became apparent that the alleged "white slave," Florence Stummie, was simply his girlfriend. Following the jury's verdict, Judge Vierck called Sussman to the bench and excoriated him for giving perjured testimony. He further charged him to tell the Committee of Fourteen not to send him back to Suffolk County again. With that, he was ordered out of the courtroom.[165]

The primary mechanism for suppressing both prostitution and illicit or extramarital sex during the Great War was the Committee on Training Camp Activities, commonly known as the "Fosdick Commission" after its head, Raymond B. Fosdick. The Fosdick Commission led the assault on red-light districts in cities and towns, but its objectives went much further. Along with its subsidiaries, such as the Committee on the Protection of Girls, the Fosdick Committee promoted "clean" activities on camps such as athletics, supervised socializing and dances and arranged reading and lectures on military camps and bases. In the name of military efficiency, it even hoped to prevent the young soldiers from even thinking about sex. The CTCA syllabus declared that "a man who is thinking below the belt is not efficient."[166] Much of the anti-prostitution, anti-sex program emphasized the very real dangers of venereal disease. Graphic photographs and drawings of sufferers, especially from syphilis, were a major element in the committee's, and government's, campaign against commercial or casual sex. "A German bullet is cleaner than a whore," as one Fosdick Committee poster phrased it.[167]

Although commercialized sex was a concern, national, state and local leaders also expressed fears that the young servicemen and young local women might fall prey to youthful indiscretions, inappropriate romances or premarital affairs. For some, the main source of venereal diseases was not prostitutes but "the type known in the military as a flapper—that is, the young girls who are diseased and promiscuous."[168] As soldiers were warned against VD, young women were enjoined to avoid any manner of behavior that might arouse soldiers, a vague and highly elastic category. All in all, the government exhorted its young men in uniform to make war, not love, and its young women to hold them to the course in the great crusade.

The Town of Huntington endeavored to do its part in maintaining the sexual purity of its young men and women. In July 1918, the Huntington Board of Health passed an ordinance prohibiting young women from appearing on the streets or highways of the town after 9:00 p.m. and before 5:30 a.m. "accompanied by a soldier or sailor unless such soldier or sailor be a member of the immediate family or…be known to the parents of such

female, and such parents have consented thereto."[169] All persons under eighteen, regardless of sex, were barred from public thoroughfares between 9:00 p.m. and 5:30 a.m. unless accompanied by parents or a male relative twenty-one or over.[170]

The local paper deemed the restrictions "a wise ordinance," going on to state that most "soldier boys are young men of excellent habits of self-control and high principles, but in a great body of men gathered from all parts of the country, it can hardly be expected there will not be some wild and immoral ones."[171] Of course, lusty young American men unexpectedly released from family and community restraints might "fall prey to temptation." Alluding to some villages near Camp Upton, the editorialist concluded that "the sad experiences of other communities on Long Island should serve as a warning to the parents or other friends of young women in our town."[172]

Blowback was swift. The commander at Brindley Field in Commack, the military base closest to Huntington, deemed the curfew insulting to his men, prohibited them from visiting any villages in the town and deployed a cordon of military police to prevent it.[173] The town leaders were stung by the implication that they were being unpatriotic and insufficiently supportive of the men in uniform, while Huntington's businessmen likewise likely feared a hit to their bottom line. The supervisor appointed a committee to consider the matter, and Huntington officials carefully detailed preparations for a recreation center for visiting soldiers. Meanwhile, the Huntington Citizens' Committee quickly organized a large entertainment program at Brindley, replete with bands, singers, comedians, a variety of food and "smokes." When the event concluded, the airmen expressed their thanks by giving three "rousing cheers for the Huntingtonians."[174]

If the troops at Brindley were mollified, Huntington's women were not. Believing their maturity, personal integrity and morality were impugned, a committee of Huntington women contracted for Manhattan attorney M.E. Harby to press their objections before the town board meeting on July 12. Harby began by asking the board if Huntington village "had fallen into such an immoral condition that protection was needed for the soldiers, or was it to keep it from getting worse?"[175] Harby went on to denounce the law as discriminatory and warned that a woman arrested under the code would have legal grounds to sue the town.

Invoking the name of the commander of American forces in France, the lawyer claimed that if General Pershing was out walking with a friend's wife, she would be liable to arrest under the terms of the ordinance. With a thinly veiled threat, Harby predicted that if the troops didn't feel welcome in

Huntington, they wouldn't visit. Worse, he asked how the Germans would use the ordinance in their propaganda.[176] Clearly shaken by the outcry over what it had deemed a reasonable measure, the board took no immediate action and sought the protection of the Fosdick Committee's name by asking it for guidance but effectively allowed the ordinance to "sleep."

Huntington was not the only Long Island town that felt the need to shield young soldiers and women from their libidos. Determined to prevent anything resembling improper behavior between the sexes, the management of Freeport's War Camp Community Service Club imposed a strict code of conduct at its dances. Proscribed behaviors included dancing more than once with a single partner, exchanging names and addresses and women entering or leaving with a man in uniform.[177]

Although Manhattan and Brooklyn newspapers ridiculed the rules, Freeport's own journal retorted that anyone who felt the code of conduct overly strict "is not invited to the clubhouse—not wanted."[178] It was left to the young men and women to find ways of making their own arrangements. In any event, Freeport was confronting the more widespread challenge of how to return the young men to small town mores "after they'd seen Paree."

Disputes and conflicts among the soldiers in the camps sometimes spilled over into the surrounding communities. In August 1917, when the 42nd "Rainbow" Division, composed of units from twenty-six states, began training at Camp Mills, sectional animosities between the 69th New York/165th U.S. and the 4th Alabama/167th U.S. resulted in brawls in camps and beyond. The roots of the fighting may have owed something to the two regiments being descended from those who had faced off against each other during the Civil War. Some of it was probably a cultural clash. The Alabamians came from rural areas and were looked down upon as inferior hicks by the New Yorkers and other northern troops. "They're country, the whole bunch," a Wisconsin recruit declared. "Got head lice and graybacks. Positively the dirtiest, filthiest gang of supposed to be men I ever saw."[179] The southerners, a long way from home and familiar faces, were also under stress from outbreaks of measles and mumps, which some observers believed was caused by their not having been exposed to "baby diseases" until they reached Camp Mills.

Whatever the cause, the results were often violent and did nothing to project American solidarity in the nation's war effort. Fights broke out when the 167th first arrived at Mills and was greeted with jeers by the New Yorkers. A few days later, two companies of Alabamians broke through

their own military police cordon and mixed it up with the "Fighting 69th." Reportedly, they were driven back to their own section "carrying bruised bodies and sore heads."[180]

The confrontations continued outside the camp. Fistfights exploded in taverns in the nearby village of Hempstead. One observer claimed that the rampaging southerners had to be brought under control by MPs with bayonets, and one was supposedly killed. "It was hell to pay, but finally the officers of both regiments, and Father Duffy [the 69th/165th chaplain], calmed down the situation."[181]

The young Alabama guardsmen were habituated to the strict and oppressive segregation of the Jim Crow South, then at its peak. Soon after their arrival on Long Island, they determined to impose their vision of the racial hierarchy on what they deemed the far too loose racial relations of New York. On one of their first leaves, they entered Hempstead village and set upon every black man they saw. According to the *New York Herald*, the Alabamians "engaged in pitched battle with many negroes on the streets of Hempstead" and even attacked porters on the Long Island Railroad.[182] Not surprisingly, rumors flew that the southern troops intended to attack the quarters of the 15th New York/369th U.S., an all-black unit. The African Americans received ammunition from the 69th, leading the southern troops to reconsider their plans.[183]

Although rowdiness, intoxication and possible loose morals among the servicemen were the main concerns for army officials as well as civilians, more serious incidents heightened public anxieties. In April 1918, four soldiers on furlough from Camp Mills stopped at Beinbrink's Hotel in Hollis, Queens County (or borough), for some drinks. At some point, they pulled out pistols, robbed the establishment and then commandeered a passing car when the police arrived. The car contained two Huntington men and one woman on their way back to the village. After a shoot-out in which one policeman and the motorists were wounded, the soldiers ran into some brush, where they were captured.[184]

Local papers tried to put the matter into perspective. "[I]n making a draft of several hundred thousand men necessarily some criminals will be included," the *Long-Islander* reassured readers. Henry Cohen of Brooklyn, the only New Yorker among the soldier-robbers, was identified as the ringleader. He was described as "a man with a criminal record and should never have been allowed a furlough."[185] While the paper wondered how such a man could purchase a firearm, they laid the principal blame for the incident at the feet of "unprincipled rumsellers and keepers of houses of ill-fame. It is

the Jamaica saloon and its inmates [that] played havoc with some of the men given furlough and visiting that place."[186]

Another soldier-related felony occurred the following month when Private Alexander Johnson, an African American soldier in the 369th Regiment, was charged with killing Mary Jones, a black woman living in Patchogue. During his trail, Johnson admitted to stabbing Jones to death but claimed it happened during a "brain storm" and was, in any event, self-defense after she had robbed him and reached for a pistol.[187] Two doctors testified that Johnson was subject to epileptic seizures and could have been in such a state when he murdered Jones. He was convicted of manslaughter and sentenced to eight to fifteen years at Sing Sing.[188]

Nor were the military installations immune from crime. On May 5, 1918, Private Michael Maloney and Mrs. J. Harrity, who was visiting him at Camp Upton, were shot by an assailant using a service rifle. Maloney was hit in the head and chest, whereupon Harrity screamed and started to run. She was then shot and killed. The murderer fled into the surrounding woods, evading pursuers from the camp who soon called in Suffolk County law enforcement.[189]

Initially, the murders were believed to be gang-related. Maloney was from the Red Hook section of Brooklyn, and the killings were believed to stem from a rivalry between two gangs, "the Hookers" and the "Pointers" (to which Maloney was said to belong). Reports circulated that the draft boards had been busy in Red Hook and that many gang members had been inducted into military service. The truth turned out to be something different. On May 14, 1918, Manhattan police, acting on information provided by Upton sentries, arrested Private Layton James of the black 369th Regiment, which at that point was stationed at Upton. He soon confessed that he had an "altercation with Maloney which led to the shooting…and that Mrs. Harrity was shot when she went to Maloney's rescue." The cause of the confrontation was not revealed.[190]

If some sort of racial dispute lay behind the killings, it would not have been totally surprising. Many at the time predicted that military service, especially the draft, would further the assimilation of the nation's pluralistic population. There seems to have been some truth in the prognostication except in one area: race. The reason was that there was no attempt at racial integration. The army had been segregated since the Civil War, and although about 290,527 back men were conscripted in 1917–18—9.6 percent of the total of number of draftees—they were placed in all-black units.

Some of these units were stationed at Camp Upton and Camp Mills, where the all-black 15th New York, a National Guard unit, did guard duty before being transferred to Spartanburg, South Carolina. Although these men came from all sections of the state, some were inevitably drawn from Long Island's black communities. However, others came to the camp as draftees. In October 1917, newspapers reported that "colored conscripts" would arrive at the camp.[191] All the black troops were housed in separate barracks.

Although black regiments had historically been officered by whites, some African Americans were promoted to junior grade officers during the war. One of these was Albert W. Sells, a member of Stony Brook's black community. On January 12, 1918, he proudly wrote a friend that "I am one of the first colored officers made out of the ranks."[192]

Along with the other regiments of New York's 27th Division, the 15th New York was sent for training at Camp Wadsworth near Spartanburg, South Carolina. The mayor of Spartanburg voiced a common fear felt by many southern whites in the Jim Crow South, namely that the black New York soldiers had been spoiled by the less overtly racist, if still discriminatory, environment of the North. Indeed, relations between white civilians and the black troops deteriorated to the point that the 15th New York was quickly shipped to France before a riot might occur. As the 369th United States Infantry, the men fought in the 93rd Division, where they earned a distinguished record.

In addition to the campaigns for women's suffrage and suppression of prostitution, another long-cherished goal of social reformers was secured under the rubric of war patriotism: Prohibition. Agitation for temperance—

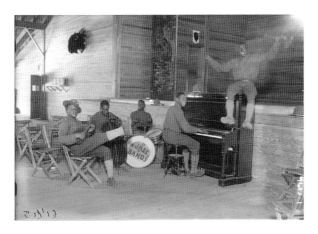

Camp Upton Jazz Band, probably including members of the 15th New York National Guard. *Courtesy of the Library of Congress.*

later reframed as the outright prohibition of the manufacture, sale and consumption of alcohol—began before the Civil War. By 1916, nineteen states had gone totally "dry," and anti-liquor advocates seized on the issues of food production and soldier's moral integrity and efficiency as arguments to drive alcohol from the nation's life. Huntington's *Long-Islander*, edited by Charles E. Shepard and Hiram E. Baylis, was intently interested in social morality and proudly boasted under its banner that it was "an Independent paper devoted to News, Literature, Morals, Temperance, etc." Freeport's *Nassau County Review* supported the prohibitionist cause by running a Woman's Christian Temperance Union (WCTU) column in every issue and sprinkling its pages with other anti-alcohol articles.

Articles and editorials (often indistinguishable) relentlessly hammered home the necessity of purging alcohol from the nation. The *Long-Islander* approvingly reprinted a letter written to the *Brooklyn Eagle* that asked "why in the world does not the Government put a stop to the annual waste, and worse than waste, of billions of bushels of grain in the production of whiskey and beer, the use of which is the cause of untold poverty, crime, and domestic unhappiness."[193] The editors applauded preliminary steps to reduce alcohol production as a wartime measure. The Food Control Act imposed a ban on the manufacture of distilled liquors, although existing stocks could still be sold.

In an editorial titled "For the Good of the Nation," the *Long-Islander* predicted that it would "not be many years before this prohibition will be the law of the land not only for the war but for all future time." Even better, future measures would apply to beer and wine as well as distilled products.[194] The beneficial effects were manifest: prohibition would lead to an "enormous increase in the productive capacity of hundreds of thousands of working men, reduction of crime, and the consequent lowering of the cost of maintenance of jails and insane asylums, and courts and peace officers."[195]

The Selective Service Act made it unlawful to sell liquor to men in uniform, although draftees could still access alcoholic beverages up until the moment they took their oath of service. In September 1917, Huntington's Home Defense League, which was active in troop support, bond selling and related activities, organized a reception and dinner for the town's draftees at Hall's Restaurant in Centerport. "An effort was made to keep…those to enter the National [draftee] Army from having beer." The committee representative "requested" Hall not to serve the beverage but admitted that the men had the right to request it. To the organizer's dismay, "some of the men went to

the barroom to get their beer, while others…respected the plea" to refrain from the unpatriotic libation.[196]

Denunciations of alcohol as deleterious to the national war effort were a constant among certain elements of the press, as well as those who undertook to stoke enthusiasm for the war and intimidate those who were perceived as insufficiently supportive. In an appearance at Huntington's Palace Theater on December 16, 1917, Captain Richmond Pearson Hobson delivered the address, "America at War," which took direct aim at alcohol, charging that its manufacture and use undercut national preparedness. "America and the Allies must become sober nations to win the war," he declared, sidestepping the question of how the French, Italians and British managed to wage war while allowing its soldiers and civilians access to beer, wine and whiskey. Even worse, "the brewers are the backbone of the liquor traffic and the Germans are back [behind] of the brewer interests."[197] The last was a thinly veiled, and widely repeated, slap at the loyalty of German Americans, whose members included the owners of most major breweries. Some prohibitionists were even more direct. One announced that "pro-Germanism is only the froth from the German beer saloon.…Kaiser Kultur was raised on beer [and] sobriety is the bomb that will blow Kaiserism to kingdom come."[198]

As the campaign for prohibition picked up steam, the army took measures to keep its men away from alcohol. In addition to the prohibition against serving men in uniform, the military attempted to impose a cordon sanitaire around its major bases, Long Island's installations included. As the largest military encampment on the Island, Camp Upton took considerable pains to maintain the sobriety and moral virtue of its trainees. When it was discovered that too many of the troops were returning to Upton "late and unsteady on their feet," the Upton commander forbade the men from entering a zone ten miles around Patchogue, East Patchogue and Sayville. Sixty military policemen were stationed near the major arteries to enforce the ban.[199] The presence of speakeasies and compliant taxi drivers was blamed for the problems.

Barring servicemen from entering enumerated villages could result in serious hardship for various merchants—not to mention the stigma of appearing to impede the nation's wartime crusade. After Patchogue and other South Shore villages were placed off-limits, Riverhead sent a delegation to Upton to inquire if they would also be blacklisted. The town representatives were relieved when the camp's authorities stated that they would not be placed off-limits if conditions remained as they were. In turn, Riverhead

officials committed themselves to remain vigilant for those providing liquor to soldiers or keeping "a disorderly house."[200]

The military ban on Patchogue, East Patchogue and Blue Point was lifted in May after the State Excise Commission imposed a prohibition on selling liquor in bottles throughout the town of Brookhaven. Bayport and Sayville in Islip Town remained off-limits for military personnel.[201] The surging forces of prohibition rolled onward when the state excise commissioner outlawed off-premises sales of liquor in the town of Huntington, purportedly to prevent sale to soldiers, although no distinction in clientele was made.[202]

In October 1918, the town of Riverhead declared itself totally dry "regardless of the Federal prohibition law" making its way through Congress.[203] The previous December, Congress had passed an all-encompassing amendment that, when ratified by the states, would ultimately mandate nationwide Prohibition in January 1920. The Great Crusade had midwifed the Great Experiment.

The febrile atmosphere caused by entry into the war, fears of shortages of food at home and for the country's allies, concerns for wartime efficiencies and the barely cloaked anti-German hostility directed at the nation's breweries all combined to achieve a nationwide prohibition of the production and sale of alcoholic beverages just in time for the soldiers' return from Europe. Whatever the negative effects of alcohol abuse, concerns that production and consumption decreased the national and Allied food supply were greatly overstated. Boasting the most productive agricultural sector in the world, the United States increased food production to meet both domestic and international needs without serious disruption.

Chapter 6

OVER THERE

Long Islanders might be found in every branch of the American armed forces, especially after the pool of draftees was tapped to provide reinforcements wherever needed. Nevertheless, two large formations were closely identified with New York: the 27th Division, which was drawn almost entirely from the New York National Guard, and the 77th Division, which was composed primarily of New York draftees. Certain regiments, most famously the 69th New York National Guard Regiment (the federally designated 165th Regiment), were also made up of New Yorkers, in the case of the 69th with a heavy Irish accent.

The experience of individual Long Island soldiers, like that of all the men in the AEF, varied greatly. Those attached to staff or in the essential Service of Supply (SOS) were ordinarily behind (often far behind) front lines, enjoying comfortable quarters, access to abundant food, village and city attractions and socialization with civilians.

Infantrymen, artillerists and other soldiers intended for combat were also able to sample the enjoyments offered by France while they were still in training in "quiet sectors" and not yet committed to action. In this preliminary phase, which was over by June 1918, the Yanks were often camped in or near civilian zones, which gave them the opportunity to test the strictures of Uncle Sam's anti-sex campaign. Members of the New York 69th/165th Infantry stationed near Baccarat in May 1918 discovered a brothel dubbed "Maison Number Two," where it looked to some observers as if an entire battalion was lined up waiting for their turn with the professional women.

The situation so flagrantly flouted official directives that MPs placed it out of bounds despite a "lot of wailing from the boys as well as the inmates."[204]

Shortly afterward, Private Al Ettinger, a motorcycle dispatch rider in the regiment, came across another whorehouse on the road to Deneuvre. He was allowed free choice of his partner if he advertised the establishment to the rest of the New Yorkers. "I had never seen women dressed, or rather undressed, that way, draped all over the room," he remembered. "But soon I became keen on a girl no older than I. She was absolutely lovely, and after a most pleasant sojourn, I took my leave."[205] Of course, not all soldiers were stationed where sex was available—commercial or otherwise—and many later reported that the army's warnings about the dangers of venereal diseases led them to abstain from sexual contact when the opportunity arose.

Once sent to the front beginning in June 1918, and especially after the launching of major offensives in September, the men of the infantry divisions had little chance to sample the pleasures of France, cultural or carnal. Instead, the doughboys lived on army rations, sometimes supplemented by Red Cross or Salvation Army kitchens if they were lucky. They faced massive shelling, gas attacks, machine gun fire, close-quarters infantry fighting and nearly ineradicable "cooties" in the form of lice. Even when pulled out of the front lines for rest and recuperation or brought back to field hospitals, they were seldom sent far enough from the front to play tourist.

Responding to a relative who sent him one of the government's booklets encouraging its warriors to maintain their virtue, nineteen-year-old ambulance driver David Atwater replied, "I received your little booklet on morals which amused me greatly. The French lieutenant was much amused and said, 'Whoever sent this does not know where we are.' Here at the front there are no women at all, even the nurses do not go so close to the front."[206] For the multitudes of men like Atwater, Paris would have to wait until the Armistice.

The 27th Division, under the command of Major General John F. O'Ryan, sailed for France on April 29, 1918.[207] Along with the 30th Division, it became the II Corps of the American Expeditionary Forces, although it was attached to the British 4th Army in Flanders. This arrangement was the single concession the AEF commander, General John J. Pershing, made in answer to Allied pleas for American troops to serve as reinforcements for Franco-British divisions bled white by the German spring and summer offensives. All other American divisions were organized in an all-American army that took over its own sector farther south alongside the French.

The 27th was bloodied in the Mount Kimmel sector, where they were introduced to the harrowing reality of trench warfare. Lifelong Islip resident Edward L. Hawkins recalled following an assault leader through the barbed wire and into "no man's land" between the lines. "And the other guys are doing the same thing, coming over to you, the Germans. Then you get together [engage] and you have a fight, with your short guns, your revolvers. I had a rifle and a gun [pistol][208].…You did most of your fighting at dusk, and early morning, break of day. That's when [the Germans] came over the top after you. They came over [one night and] I never saw so many. All you had to do was shoot—you couldn't help but hit 'em. You didn't have to aim to tell the truth. And you could see them falling. And they were hitting us too."[209]

In late September, O'Ryan's New Yorkers were positioned to take part in the assault on the Siegfried or "Hindenburg Line," a formidable defensive network anchored on the St. Quentin Canal and tunnel complex. Before the main attack was launched on September 29, 1918, the Americans were introduced to a venerable, and welcome, British military tradition. As one doughboy fondly remembered, the British provided each man with "a big tumbler of rum before the charge, and thank God for that."[210] The troops went "over the top" at 5:30 a.m., and by 8:10 a.m., the 27th had gouged out a breach in the German defenses. Murderous fire prevented any further advance until the Australian Corps came up in support. The two Allies renewed the assault, forcing the Germans out of their elaborate defensive network and opening the way to further advances in Flanders.

The cost was high, with the division suffering 1,540 casualties.[211] The division's 107th Regiment alone lost more than half its men, the heaviest loss by a single American regiment during the war.[212] Twelve members of the 27th received the Medal of Honor for heroism during the fighting at the Hindenburg Line. Among these was the posthumous award to 1st Lieutenant William Bradford of Garden City, who led a small squad of men over three lines of German trenches, destroying several machine gun nests in the process. Despite being wounded three times, he and a dwindling number of his comrades had fought their way into a fourth trench when they were cut off by a German counterattack—Bradford was killed.[213] Major General O'Ryan was among the four officers who received the Distinguished Service Medal for exceptional leadership in the battle. New York's most highly decorated soldier, Richard O'Neill, a recipient of the Medal of Honor, fought with the 69th/165th Infantry of the Rainbow Division.

Following the struggle along the Hindenburg Line, the 27th and 30th Divisions took part in the British offensives toward Cambrai and Selle before being relieved on October 12 for rest, reinforcement and reorganization. The Armistice was signed before they could return to the front. In total, the division served fifty-seven days in the front lines. The men finally sailed for New York on February 26, 1919.

The 77th Division—also known as the "Metropolitan Division," the "Liberty Division" for its insignia or "Melting-Pot Division" from the substantial number of immigrants and languages found within it—was organized at Camp Upton and began shipping out from New Yok on March 27, 1918. It had the distinction of being the first National (draftee) Army division to reach Europe and the first of its type to take responsibility for a battlefront sector. Like all the American divisions, it was initially placed in a "quiet" sector for training, first with the British and later with the main American forces in Lorraine and the Champagne region.

Although contact between the troops of New York's 27th and 77th Divisions was near impossible due to their widely separated deployments, the 77th encountered a large body of fellow New Yorkers when the 69th/165th Regiment passed them on their way toward Chateau-Thierry in early August 1918. Being New Yorkers, they immediately began exchanging barbed comments. The 42nd Division had fought in the tough battles around the village and sneered at the arriving 77th troops for being draftees. "We was over here killin' Dutchmen before they pulled your names out of a hat," one 69th doughboy yelled. "Well, thank God we didn't have to get drunk to join the Army," came the retort.[214] "Hell, we thought the 69th had all been gassed," a Metropolitan Division soldier ventured, receiving the reply, "D'Boche tried to, idiot, but we smelled 'em first. They'll get you sure."[215] But the insults soon gave way to queries about home—neighborhoods, parishes, schools, friends and relatives. Before long, groups of doughboys from both units joined in singing "East Side, West Side," the city's unofficial anthem.[216]

The men of the 77th marched through the ruins of Chateau-Thierry and were soon embroiled in what their commander, Major General Robert Alexander, called the "hellhole of the Vesle," a small river valley that produced heavy casualties. The 77th later took part in the Meuse-Argonne offensive, which began on September 26. The Meuse-Argonne, with its extensions, was the longest, most concentrated and most costly American operation of the war, lasting almost to the Armistice. In the forty-seven

Setauket soldier Raymond Wishart before shipping out for France, early 1918. *Courtesy of the Three Village Historical Society.*

Long Island and World War I

Raymond Wishart's original grave in France. He succumbed to the effects of gas in August 1918. *Courtesy of the Three Village Historical Society.*

days of combat through the ravines, woodlands, farms and villages of the Argonne Forest, the AEF suffered an average of 550 men killed in action each day, with many more wounded.

The Meuse-Argonne witnessed the saga of the 77th's "Lost Battalion." Pershing and his lieutenants pressed their men to push forward almost regardless the cost, and the "Lost Battalion," six mixed companies of 541 men, outpaced the units around it and found itself in a deeply wooded ravine—not "lost" but surrounded by German troops. The battalion, commanded by Major Charles S. Whittlesey, a New York City lawyer, was subjected to continuous shelling, sometimes by American artillery unaware of their position. Although his little force was ground down by repeated German attacks and shelling, Whittlesey ignored a German offer to surrender. Despite hunger, cold and incessant attacks, Whittlesey held his men together for six days until American troops finally broke through the encircling Germans. Of the more than 679 men who began the struggle, 252 emerged from the woods.[217]

Whittlesey, who received the Medal of Honor for his leadership during the six-day ordeal, survived the war physically but could never shake the horror of his ordeal in dark, murderous Argonne. After putting all his affairs in order, he disappeared from a ship returning from a sojourn in Cuba in 1921. His death was widely seen as a belated casualty of the war.

When it arrived in the Champagne region in August, the 77th Division numbered 25,553 men and 958 officers. While it received thousands of replacements during the fighting, it ended the war with 20,973 and 831 officers.[218] Total losses for the division amounted to 17,000. The number killed in action from Long Island, including Brooklyn, totaled 320.[219]

Commack native August Edward Swenson kept a diary of his time in the 77th Division as it fought through the Champagne and Meuse-Argonne. Though a member of a machine gun battalion, he served mostly as a headquarters messenger, duty that sent him back and forth from the rear echelons to various parts of the division's front lines. A constant theme in his notations, which extended from April to November 1918, was the prevalence of heavy artillery fire and frequent aerial action, including reconnaissance, dogfights and sometimes German bombing runs on American troops. On July 5, which he described as a sunny day, he watched as a German plane fell to earth after being hit by antiaircraft fire. The plane was "tumbling over & over on the way down. It seemed to take about five minutes before it crashed to splinters 100 yards from our place in the woods.…One German officer and one German soldier [enlisted man] was among the wreck. The Germans were unrecognizable."[220]

Swenson and his comrades buried the German flyers with full military honors and then turned to slicing off pieces of the plane's canvas-covered fuselage. "Before long the boys will have mailed most of the German plane back to the states as souveniers [*sic*] of the war."[221]

Artillery fire, responsible for 70 percent of casualties in the war, was noted on an almost daily basis: "Our artillery guns sending four gas shells over to the Germans"; "Plenty of artillery shells going & coming, whistling overhead at intervals, for 24 hours" (July 28); "Saw many horses & mules that apparently were caught in an artillery barrage and blown apart" (August 12); "More gas coming from the Germans" (August 16); "Shells from German artillery dropping nearby all day" (August 18); and "Artillery firing heavy as usual. German planes dropped a few more bombs after dark" (August 23).[222] If anything, the cannon fire intensified as the 77th entered the Argonne.

Swenson recorded more than artillery barrages and aircraft duels. Like all the troops in or even near the front lines, he dealt with the

The fighting in the Argonne, as depicted by a 77th Division artist. *From* History of the 77th Division *(1919).*

constant presence of death. "The smell of the dead in the valley was terrific, had to walk very slow and watch the ground in order not to trip over a dead soldier, mule or horse," he wrote during combat in the Vesle Valley. Gas did not shred or dismember bodies, but it left its own distinctive death notice. Up north in Flanders, Edward L. Hawkins remembered that "we seen a lot of dead fellows laying around that were gassed. When they were gassed their faces turned all black, just like a mulatto. They were just like colored people."[223] Corporal Martin Hogan of the 69th/165th remembered the "nightmare smell of the battlefield. Sometimes [it] forces men to don gas masks.... [T]he peculiarly penetrating and arresting odor of the battlefield's overripened fruits of men and animals is one of the hardest features of war to become accustomed to."[224]

As September turned into October, the tide of war shifted decisively as American and Allied forces drove the Germans back to their own borders. The Yanks might have sensed that the inexorable tide of war was running in their favor, but the Germans—despite running out of supplies, experienced troops and hope—continued to resist. Some fought ferociously, while others showed signs of increasing deprivation and demoralization. One Long Island soldier wrote home that "all the Germans I have seen were so thin and tired I do not think they could goose step if they tried."[225]

Swenson did not comment on the appearance of German POWs but reported the pleasure of resting in captured German dugouts, recreational facilities and showers, a welcome treat for mud- and lice-covered men. "Packed up to advance and arrived in valley among German dugouts & summer gardens," he wrote on October 1. "Saw many German prisoners being taken to the rear. Our men made themselves at home in the 2 room dugouts that the Germans had built, and had been using the past 4 years."[226] On October 12, in "the heart of the Argonne Forest," Swenson

reported hearing "joyful yells in the surrounding hills as the false rumor was circulated that the Germans had accepted peace terms."[227] They had almost a full month left to endure.

Brooklyn native William W. Nicoll, who served in the 313th Infantry Regiment, remembered the fighting in the Argonne as chaotic and murderous, especially the struggle for the key position of Montfaucon. "As you came out of the woods the Germans were waiting for us there. They were mowing us down with machine guns.…We were shooting the best we could. Where we could see something moving we would shoot that way. We couldn't do too much because we were advancing."[228] After finally taking Montfaucon, many of the surviving doughboys seemed almost let down. "We took the town, but it was all rubble. All the buildings were shattered. So, we said, 'Is this what we're fighting for?'"[229]

Nicoll himself was wounded in an assault on German positions. "I got two machine gun bullets in my right leg and shrapnel in my knee. Another one bounced off my elbow."[230] After receiving some immediate first aid, Nicoll lay out on the field waiting to be taken to a field hospital. "I was laying in a low trench. They [medics] put a couple of rifles over the trench and put a shoe on top of each one, so they could tell where I was.…I was there from about 11 o'clock in the morning to about 7:30 at night."[231]

Swenson's comments on the last ten days of the war chronicle incessant artillery fire, continuous advance and heavy casualties. "Artillery barrage ended about 7AM. Infantry boys advanced…and captured a few hundred German soldiers as they came out of their dugouts & hiding places.… Prisoners said the shells exploded so close together that it was impossible for any living thing on the surface…to get away alive" (November 1). He followed this the next day: "Saw many American dead and wounded around here.…A German plane that had crashed or maybe shot down was nearby. The plane was of many colors, this kind was attached to the Richtofen group. The German aviator lay nearby, his head missing. Later in the day, after the Germans had retreated some of the boys searched the area, but could not find the aviator's head."

Similar remarks continued right up to the Armistice: "Many dead horses & mules around," "Many dead around, Americans & German" and "Many dead horses & mules. Ambulances loaded with wounded going back all day." Finally, on November 11, he noted, "Advanced 5 miles to Raucourt and saw civilians for the 1st time in 5 months. Little artillery & machine gun firing in the A.M. Quiet during the afternoon. Heard during the afternoon that the Armistice was signed at 11A.M. ending the War."[232]

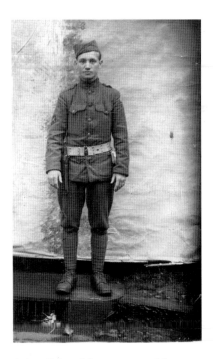

August Edward Swenson posed for a post-Armistice picture in Morannes, France, March 25, 1919, shortly before his return to the United States. *Courtesy of Susan Elizabeth Hallock.*

As the number of dead on both sides accumulated rapidly in the autumn of 1918, front-line troops witnessed or joined the depressing and sometimes sickening but necessary work of the burial parties. "It kind of hurts you, you know. Seeing those fellows, going with them, and knowing them good, and then coming along and seeing them lying there dead," one Long Island veteran recalled.[233] As for the front-line burials, "They dig a big hole, a ditch, like. It was around 15 feet deep. Tractors would go down in this place and dig it right out. Then they'd come along and lay the bodies down. They'd take a row, then they start coming back on top of it, after putting so much dirt on them, another layer [of bodies]. They kept doing that [until the burial trench was filled.] They'd bury you there, then they'd turn around, when they got time, take you out [exhume the bodies] and send you back to the States. Put you in an ordinary box."[234]

Long Islanders were among the flyers Swenson witnessed dueling and sometimes falling from the skies above the lines. The first American aviator killed in combat during the war was Captain James Ely Miller of Smithtown. He had received flying lessons at Plattsburgh and went on to help organize the First Aero Squadron, which became the nucleus of the Army Air Service. In July 1917, he was sent to France, where he helped establish the American army's first overseas flying school. But he craved action and was transferred to the front in January 1918, taking command of the 92nd Pursuit Squadron one month later.

On March 9, 1918, he set out on a patrol with two other pilots. They were all flying French SPAD XIIIs. Engine problems forced one of his fellows to return to base, and the other had to disengage when his machine guns malfunctioned. Miller was left alone in a dogfight with two German fighters that had challenged his group and was shot down in the contest.[235]

The next day, a German pilot flew over Miller's airfield and dropped his personal effects on the runway.

When the American Legion was established after the war, the Smithtown post took Miller's name in his honor.[236] Ninety-nine years after his death, Miller was posthumously awarded the Distinguished Flying Cross at a twilight tattoo held at Joint Base Myer-Henderson Hall in Virginia. His great-grandson Byron Derringer accepted the honor on behalf of the family.[237]

It was not uncommon for troops to hold military honors for fallen foes, and this seems to have been followed more by the air services, which had fewer personnel, than by any other branch. When Theodore Roosevelt's youngest son, Quentin, was shot down on July 14, 1918, the Germans buried him with appropriate military ceremony.[238] Though he put up a brave and stoical front, the ex-president, already in declining health, was devastated by his son's death. He died shortly after the end of the war on January 5, 1919.[239]

Lieutenant Thomas Hitchcock Jr., member of a prominent family in wealthy Old Westbury, joined the *Lafayette Escadrille* during the war. Shot down and captured by the Germans, he jumped from a train carrying him to a POW camp and managed to avoid recapture for eight days before finding asylum in neutral Switzerland. After the war, he became the dominant American polo player—some say the best—in the heyday of the sport in the 1920s and '30s. During World War II, he served as an assistant air attaché in London with an air corps rank of lieutenant colonel. He was killed after failing to pull out of a dive while test-flying a P-51 Mustang in 1944.

Long Islanders serving in the U.S. Navy ordinarily found their duties more routine. While German U-boats prowled the Atlantic, sinking American and Allied vessels, the institution of the convoy system prevented them from seriously interdicting the flow of men and supplies to Europe. Most sailors found themselves in the necessary but conventional duties of screening convoys, ferrying American troops to France and, when the war ended, returning them to the United States.

Nevertheless, the waters off Long Island became the site of the United States' single greatest naval loss during the war. On July 19, 1918, the USS *San Diego* was steaming off Fire Island on its way from New Hampshire to New York to perform convoy duty when it hit a mine laid by a German U-boat. The *San Diego* quickly began to settle, and the crew was ordered to abandon ship. Twenty-two minutes after the explosion, the large vessel was gone. Through thorough training, cool behavior and able leadership, almost all the officers and crew were saved. Only six men were lost as the ship went under the waves.

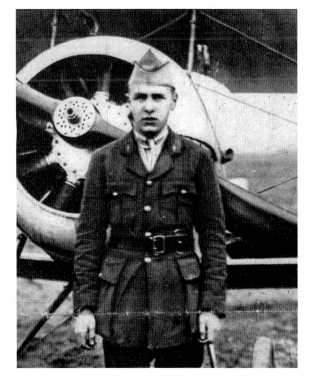

Right: Old Westbury resident and future polo star Tommy Hitchcock in his *Lafayette Escadrille* uniform, circa 1918. *Courtesy of the collection of the Suffolk County Historical Society Library Archives.*

Below: The United States Navy's greatest single loss occurred when the USS *San Diego* was sunk by a mine laid by a U-boat. *Courtesy of Frank Whitten.*

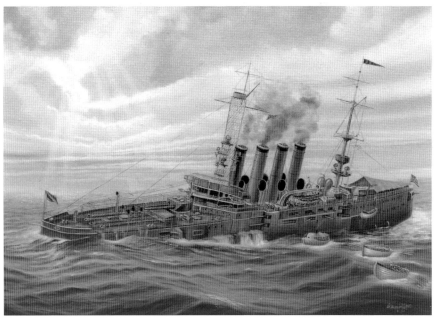

Long Island and World War I

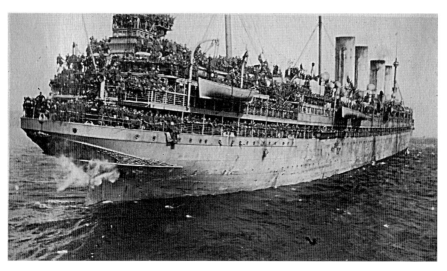

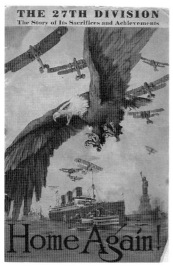

Top: U.S. model 1917 helmets bearing the insignia of two New York–based divisions, the 27th (*left*) and 77th. *Courtesy of collection of Noel Gish (left) and private collector (right).*

Middle: Members of the 77th Division arrive in New York Harbor on the USS *Agamemnon*, formerly the German liner *Kaiser Wilhelm II*, April 29, 1919. *Courtesy the collection of James Boyd.*

Left: Souvenir pamphlet welcoming home the 27th Division, the New York National Guard. *Author's collection.*

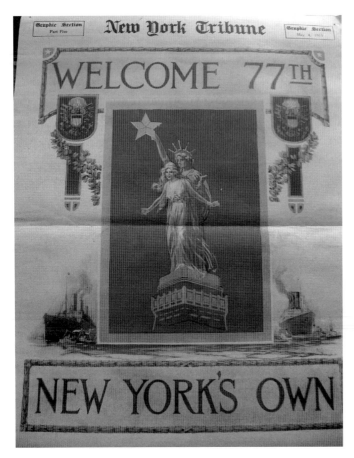

Left: Newspaper supplement celebrating return of the 77th Division. *Author's collection.*

Below: Reviewing stand admission ticket for the 77th Division's Victory/Welcome Home parade. *Courtesy of the Longwood Public Library's Thomas R. Bayles Local History Room.*

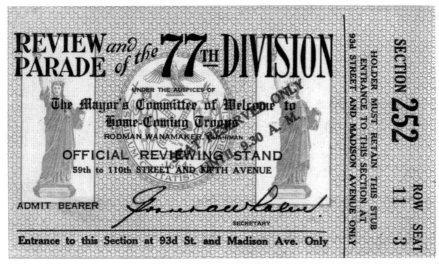

The *San Diego* lay bottom-side up in the Atlantic mud and sand until its site was rediscovered by sports divers in the 1960s. Several divers died exploring the sunken vessel, and the navy threatened to declare the site off-limits after some scuba divers began bringing up still live, and now unstable, ammunition. The threatened prohibition was not put into action after dive boat captains agreed not to allow any divers to handle such ordnance.[240]

With the war won, most American divisions—except a few, including the 42nd, which briefly served on occupation duty in the German Rhineland—expectantly waited for the orders that would assign them a troop ship to transport them home. The 27th Division departed from Brest on February 26, 1919, and reached New York one week later. The men were honored with a Victory/Homecoming parade up Manhattan's streets, passing under a Victory Arch specially erected at Madison Square and 5th Avenue. Proceeding farther north, the men marched by an "Altar of Liberty" set up in front of the 42nd Street Library. The parade was led by the division's wounded, who rode in cars for the occasion.

Among the patriotic decorations greeting the men was a huge service flag bearing more than 1,900 gold stars representing those killed in action or who had subsequently died of wounds. Eight black horses drew a caisson loaded with flowers and wreaths that memorialized the sacrifices of those who had fallen. Following the parade, the veterans were fed and honored at restaurants throughout the city. The troops were officially discharged at either Camp Upton or Fort Dix.[241]

The 77th returned to New York on April 29, 1919. Many of its veterans arrived on the USS *Agamemnon*, which had been the German liner *Kaiser Wilhelm II* before being seized by the United States. The returning New Yorkers were given their own parade on May 6, 1919. They also were released from the army at Camp Upton.

For the returning soldiers, and the friends, families and citizenry who welcomed them, feelings of exultation and achievement mixed with concerns for employment and the future, as well as increasing uncertainty about what future course the nation should take.

Chapter 7

VICTORY, PEACE AND NORMALCY

On November 7, the United Press Service released a false report that an Armistice was signed, Germany had surrendered and the war was over. Impromptu celebrations broke out in major cities and reached some Long Island towns. In Amityville, the local paper posted printed sheets announcing the alleged Armistice on the windows of its office building. Soon, word of the hoped-for end of the war spread throughout the vicinity, resulting in spontaneous expressions of joy. Church bells pealed, factory and fire department's sirens blew and citizens paraded through the streets waving flags and cheering. The crowds began to fade in midafternoon after it became known that the State Department had not confirmed the Armistice report. Disappointment followed uncertainty when it was revealed that the peace reports were bogus.[242] Though a letdown for those who longed to see the fighting end, the celebrations provided good practice for November 11 and the days that followed, when outpourings of triumph and relief greeted the real end of the war.

Along with the rest of the nation, Long Islanders had been following the inexorable advance of Allied manpower and matériel with mounting anticipation. As October turned into November, the Central Powers began to disintegrate. Germany's allies—the Ottoman empire, Bulgaria and Austria-Hungary—fell one after another, asking the Allies for ceasefires pending a complete peace treaty. On November 5, the German navy mutinied at Kiel, and revolution spread throughout the empire. Kaiser Wilhelm II was forced to abdicate and left for a lifetime of exile in the

Netherlands. On November 10, the German empire was abolished and Germany declared a republic, meeting one of Woodrow Wilson's requirements for the end of hostilities. The end finally came on November 11, 1918—at the eleventh hour of the eleventh day of the eleventh month—as an Armistice finally stilled the roar of war.

As victory seemed assured, attention was increasingly directed toward the ensuing peace settlement. As early as October, with the Meuse-Argonne battles raging, Huntington's *Long-Islander* called for punitive peace terms on Germany, demanding the overthrow of the Hohenzollern dynasty and seizure of all German ports until it made reparations for destruction during the war.[243]

Two weeks later, the paper elaborated its formula for a hard peace when it insisted on no armistice until the German army surrendered unconditionally and German prisoners of war held "until the last vestige of the Hohenzollern family and all the military ringleaders in this awful crime upon humanity are either made to suffer death or imprisoned in some of the countries of the Allies for life and Germany has a republican form of government." Furthermore, German diplomats should be barred from any peace conference, and a peace treaty should be simply handed to them to sign. In the editorialist's thinking, the peace settlement should "as far as possible insure a reign of democracy throughout the civilized world and make this a better world to live in."[244] In many ways, the *Long-Islander*'s recipe for a peace treaty proved prescient. German representatives were excluded from the peace conference that drew up the harsh Treaty of Versailles. Conversely, the newspaper's hopes for "a reign of democracy" and a better world were not realized.

Paradoxically, the Huntington paper supported Woodrow Wilson's Fourteen Points, his proposed framework for a peace conference. Although it demanded the overthrow of the German monarchy, the return of Alsace-Lorraine to France and the German evacuation of its occupied territory, in general the president's peace proposals were even-handed. The last point, and the one on which Wilson placed his greatest hopes for a stable world order, was the creation of the League of Nations, a prototype of the later United Nations. The *Long-Islander*'s opinion writers seemed to detect no contradiction between their calls for a hard treaty and support for the administration's softer proposals.

They were outraged, however, when Wilson pushed for Democratic victories in the fall Congressional election. The paper countered that Republicans had loyally supported the administration in the war and

charged that Wilson had been weak in the 1914–17 years and "never stood for the protection of American citizens as he should." "Does he expect that he should be sole dictator in the settlement of peace terms with Germany?" the writers asked. "Congress has all along given the president dictatorial powers in the management of the war, but it would be unsafe for the Senate to abdicate its functions in the framing of a peace treaty with Germany and Austria."[245] Though only a local publication, the *Long-Islander* was voicing signals of nascent opposition to Wilson's leadership that would grow in the months ahead. Ominously for the president, the Republicans, whose postwar objectives differed from Wilson's, captured the Senate in the fall elections.

Although the war was coming to an end, a nationwide fundraising effort, the War Work Week, was launched just as the Armistice was announced. Money realized was to be primarily distributed among the various volunteer agencies providing services for the troops. In case anyone was lulled into complacency by swirling rumors of peace, newspapers ran notices cautioning that "anyone who says this war is over is a Slacker."[246] Despite the war's end, or perhaps because of it, citizens in Nassau and Suffolk raised $500,741.73 during the War Work campaign.[247]

Everyone was primed to celebrate when the war really ended on November 11. In Huntington, business was suspended as demonstrations were organized, replete with flags, sirens, horns, guns and trumpets.[248] Five thousand citizens lined Main Street cheering quickly organized parades of civilians, soldiers, the fire department and the Boy Scouts. The procession included floats representing America and its Allies, on which women personifying Columbia, Allied nations or Liberty rode, smiled and waved.[249] As usual, the Kaiser was brought in for special abuse. A hearse drove through the street festooned with signs bragging "We've Got Him" and "Kaiser Bill Inside." Another car dragged the fallen emperor's effigy through the streets until it was finally strung up and burned. "Huntington never in her history cut loose with the freedom marking her Peace demonstration of Monday evening," an observer wrote, adding approvingly, "nor could there be imagined a greater freedom from unseemliness that was evident in the riot of rejoicing that began with the fall of night."[250]

The mixture of joy, triumph and relief was replicated across Long Island. Putting its premature celebrations to effective use, Amityville staged a festival of victory with a parade of schoolchildren, Boy Scouts, Red Cross workers, the Home Defense Corps, fire departments and factory workers who had been given the day off to celebrate.[251] Farther east in Riverhead, the village waited a week to get things in order before letting go with a

**Daniel H. Tuthill
1897 - 1958**

In World War I, Daniel Tuthill of Jamesport served overseas with the Ambulance Section of the U.S. Army, and was the first soldier in Suffolk County to be awarded the French War Cross.

Image from the Riverhead Pictorial Collection of the Suffolk County Historical Society Library Archives.

Riverhead soldier Daniel Tuthill. *Courtesy of the Suffolk County Historical Society.*

massive celebration and "Victory Ball." Preliminary events included parades headed by troopers from the "State Constabulary" (police), a band from Camp Upton, New York Guards, Knights of Columbus and Boy Scouts. Almost mandatory by this time, an effigy of Kaiser Wilhelm was conveyed through the village to the delight of onlookers.[252]

Sometimes the troops feted the townspeople. The 277th Aerial Squadron, stationed at Brindley Field, hosted a dance for local women at Northport's Bijou Theater on November 22. Adelaide's Jazz Band was brought in from New York City to provide the music. When Brindley Field was decommissioned early in 1919, the Northport Community Association reciprocated, organizing a farewell party for the departing airmen.[253]

Many communities organized welcoming galas for the troops as they returned from Europe. Between January and June 1917, the Huntington Soldiers and Sailors Reception Committee groups hosted four special galas honoring veterans. The celebrations began in Huntington village, after which the servicemen, escorted by a contingent of Boy Scouts, were driven to Ward's

Long Island and World War I

"Our Heroes" parade greeting returning veterans, Setauket, 1919. *Courtesy of the Three Village Historical Society.*

Restaurant in nearby Centerport for a "shore dinner." After being fed, they returned to the Palace Theater for the official ceremonies, conducted by religious and civic leaders. The troops were presented with a special medal the town had commissioned for its veterans. Following the formal rituals, the troops were treated to a movie and sometimes a vaudeville program. The fare at the April 29 return ceremony was titled *The Fighting Roosevelts*, which depicted the experiences of the former president's children overseas. Of the four Roosevelt boys, one, Quentin, had been killed in combat, an event that likely contributed to his father's death the previous January.[254] Archie and Theodore Jr. had been wounded in the fighting. Only the depressive Kermit had emerged physically unscathed. Theodore's younger daughter, Ethel, had served as a Red Cross volunteer during the war.

Some villages waited until all or most of their men had returned before throwing a huge blowout. The Fourth of July provided the perfect setting for such outpourings of gratitude and patriotism. Riverhead's Independence Day celebrations were used to honor the returning local troops, four hundred of whom were in an attendance.[255] In addition to the veterans, two hundred girls from the village's Polish community strode down the parade route in outfits that collectively produced the Stars and Stripes. Several floats were drawn through the streets, interspersed with bands, including one from the Bayles Shipyard, the Riverhead Brass Band and the Polish Band. Though not as grand as that erected in Manhattan, Riverhead had erected its own

Right: All four of Theodore Roosevelt's sons served during the war. His youngest, Quentin, was killed in a dogfight with German fighters on July 14, 1918. *Author's collection.*

Below: Red Cross volunteers welcoming home local veterans, Setauket, 1919. *Courtesy of the Three Village Historical Society.*

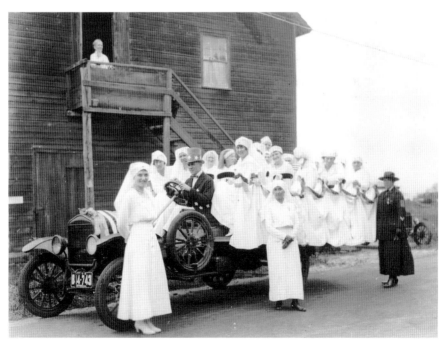

"Victory Arch" over which a "Welcome Home" sign had been affixed. The more formal events included an address by Brigadier General Evan M. Johnson, who had commanded the 77th Division from December 1, 1917, until May10, 1918. He concluded the formalities by awarding a village service medal to two hundred of the discharged soldiers.[256]

With the official itinerary out of the way, the troops were taken for dinner at the village's several hotels. The partying continued after nightfall, as the village had illuminated the streets with electric lights and Japanese lanterns. A block party on Griffin Avenue featured several bands pumping out dance music for happy revelers. The festivities ended at midnight, when the bands quit and the revelers made their way home.[257]

Freeport on the South Shore of Nassau County held its "Welcome Home Parade" on September 1, 1919. The parade was led by 222 men and 1 female service member, although newspapers still lamented that not all the village area's troops could be present.[258] As the marching vets strode by, a group of women tossed flowers at their feet. The parade—which included police, fire departments, politicians, Civil War and wounded veterans riding in automobiles, War Camp Community Service members, Knights of Columbus and Elks—snaked through the village while a plane circled overhead. Following the review, dinners were provided in two large tents. Despite a storm, attendees reveled into the evening at a block dance.[259]

One unfinished piece of business from the war offered Long Islanders yet another opportunity for public displays of patriotic enthusiasm. The Fifth Liberty Loan, scheduled for the spring of 1919, was converted into a "Victory Loan." As with previous money-raising efforts, it was designed to help pay for the war, but with the added inducement that it would aid transporting the men back from France. To gin up subscriptions, a "whippet" tank was dispatched on a circuit of Long Island villages as the centerpiece of bond rallies. A rally held at the Riverhead Casino on May 1 included a raffle drawing for a German helmet and the screening of the movie *The Price of Peace*, featuring documentary army footage from the battlefields.[260] Locally, the Victory Loan campaign seemed a success and was reported as oversubscribed in some villages.[261]

The use of captured German equipment as props in loan rallies or as raffle prizes was matched by a growing interest in collecting wartime artifacts as pieces of history. In July 1919, the Huntington Historical Society asked for donations of "relics" of the war.[262] The society opened its "Historical House" on July 4, displaying items already acquired, mostly German helmets, shells, buckles and bayonets, as well as other souvenirs

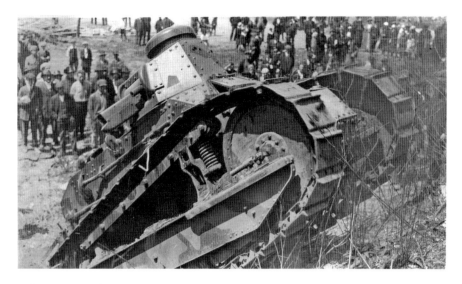

"Whippet" tank demonstration at the 1919 Victory Loan rally, Northport. *Courtesy of the Northport Historical Society.*

the doughboys had brought back home with them. A "Melting Pot" was set up at the building to collect donations to the Red Cross.[263]

Aside from parades, dinners and medals, volunteer and governmental authorities began to address the need for employment or training for returning Yanks. Posters that had aimed at drumming up support for the war now exhorted employers to find jobs for veterans. Special concern was expressed for those wounded or maimed in combat. The federal government established a Bureau of Returning Soldiers and Sailors to aid those looking for work. Offices were established in Mineola, Glen Cove, Locust Valley, Riverhead and Patchogue. Likewise, the Social Welfare Association of Nassau County was founded in Freeport specifically to assist wounded veterans find work if they had lost their sight, hearing or limbs.[264]

Some wartime injuries were more difficult to diagnose and treat. Army and government medical officers were aware that wounds could be more than physical. The phrase "shell shock" was coined during the war to describe severe emotional and mental trauma caused by combat, particularly the horrendous use of massed artillery. However, unless a soldier totally broke down into catatonia or hysteria, it often went undetected. Many men returned bearing deep psychological wounds that never healed, plaguing them and those around them until the day they died. The Lost Battalion's Major Charles Whittlesey was prominent among such victims.

Long Island and World War I

An ornately patterned 77th Division helmet. *Courtesy of the Brookhaven National Laboratory, Camp Upton Collection.*

Most of the sufferers possessed little or no notoriety. Among these was August Edward Swenson, the diarist of the Meuse-Argonne. He entered the army as a seemingly pleasant, well-adjusted young man. He returned to Commack, Long Island, and attempted to resume his civilian life with his wife and young children. Instead, his family watched as his behavior became more volatile, characterized by angry outbursts, domestic abuse and alcoholism. His marriage was destroyed, and his disrupted and devastated family became collateral damage of the Great War.[265]

As the armies demobilized, several of the Island's key military installations disappeared. Both Brindley and Lufbery Fields, which had been adjuncts of Hazelhurst and Mitchel Fields, were closed. Before being officially shut down on April 7, 1919, the Lufbery aviators expressed their appreciation for community support by holding two dinner parties for members of Freeport's War Camp Community Service.[266] Camp Mills, through which 1.5 million men had passed during the struggle, ceased operations on August 19, 1919. Although the U.S. Army Air Service retained Mitchel Field, it relinquished nearby Hazelhurst, which became a civilian airport, taking the name Roosevelt Field in commemoration of Quentin Roosevelt.

Farther east, Camp Upton also ended its wartime career. As elsewhere, the government auctioned off all equipment, structures, supplies and the like but retained ownership of the property. Upton was reopened as a transit and convalescent camp during World War II and later became the site of Brookhaven National Laboratory.

Like most Americans, Long Islanders followed the progress of the peace conference and Woodrow Wilson's efforts to ensure the inclusion of the call for a League of Nations in the final treaty. From Wilson's perspective,

Left: After the war, the government relinquished ownership of several of its installations, including Camp Mills and Hazelhurst Field. All buildings and supplies at Camp Upton were auctioned off, although federal ownership of the site was retained. *Courtesy of the Longwood Public Library's Thomas R. Bayles Local History Room.*

Below: Volunteer support organizations, including the Jewish War Council, provided stationery to troops. This card allowed a soldier to let his family know he had returned to the United States and was at Camp Mills, probably for discharge, 1919. *Author's collection.*

the League would prove the best guarantor to ensure peace, tranquility and progress in the future. The *Long-Islander*, never shy about expressing its politics, threw its wholehearted support behind the presidential goals, sometimes in grandiose, if not paternalistic, language: "We shall do our share in assuming 'the White Man's Burden' and help educate the people of Armenia, Syria, Persia, Mesopotamia, Turkey, and the natives of Africa to a state of civilization such as prevails in England, France, and our own country."[267] It was, the editorialists proclaimed, the mission of the United States to help the benighted "keep step in the onward march of progress and enlightenment," as well as to prevent weak and undeveloped countries from exploitation by "greedy neighbors." Such a program, the paper enthused, would preserve future peace. The editors went on to criticize voices in government who opposed American intervention in potential trouble spots under League leadership on the grounds that the League's proposed charter violated both the Constitution and republican principles.[268]

As the peace treaties were hammered out in Paris, opposition to the League of Nations grew in and out of Congress. The major criticism, voiced primarily by Senate Republicans, was the potential for the League to commit American military forces to combat without Congressional approval. Though a Republican publication, and often critical of Wilson, the *Long-Islander* enthusiastically supported the president in this matter. It charged that the wishes of the American people were not found "in the coterie of Senators who are now opposing the League apparently for creating political capital, and who are…posing all sorts of fanciful objections to this plan which is one of the greatest ever worked out in any international council in the history of the world."[269] Thinking people, the editors argued, have the votes to ensure that the treaty, which included the League, would be approved.

Integral to the Huntington paper's paradoxical support for Wilson's brainchild was its deeply rooted belief in the mission of the United States to assume the mantle of the world's leading power. The war had revealed the United States as the most powerful financial and economic nation. Entering the struggle when it did, and on the side it did, determined the outcome. Now it was time for the United States to embrace its responsibility as the global power. "All the earth is now looking to America as the new world power in a new, larger, and vastly better sense than that arising from any military power or achievement of conquest," the *Long-Islander* asserted.

The opportunity is ours to take the lead of the nations of the world as an impartial arbiter in the settlement of disputes as a fearless and unselfish

champion of the down-trodden, a missionary of light and freedom, a leading member of the great League of Nations underwriting the peace of the world and insuring to every country the right to live and develop its own resources unhindered and unfettered by unscrupulous and more powerful neighbors. This will prevent social unrest and the spread of bolshevism.[270]

Across the Island, the *Nassau County Review* saw things differently. In May, the paper noted the number of senators opposed to the League and voiced its approval. Referring to Wilson's senatorial opposition, the *Review*'s editorialist declared, "The United States is confronted with the question of whether the judgement of one man [Woodrow Wilson] is better than that of thirty-nine."[271] Moreover, "The Peace Conference was called for one single purpose, that effecting peace between the Central Powers and the Allied nations. The League of Nations was an extraneous subject gratuitously injected without any sufficient reason. Members of the Senate very properly protested against it, they will also very properly make their protest effective."[272]

With the Senate clearly not willing to provide the Constitutionally required two-thirds majority necessary to ratify the treaty, the debate, essentially over the League and the direction of American foreign relations, intensified across the country. Those in favor of ratifying the treaty as written, with membership in the League included, strongly supported Wilson and his efforts. Others were equally adamant in opposition. For critics of the League, it was a matter of sovereignty. "If you were a member of the United States Senate, would you vote to ratify a Treaty that bound the United States to a League in which the United States had only one vote while Great Britain had six," the *Nassau County Review* asked, referring to Britain's imperial and commonwealth partners. "If so," the paper continued, "would you class yourself as one sixth American and five-sixth British?" Anyone who did was, in the *Review*'s opinion, "a mongrel."[273]

Wilson took his campaign to the public, traveling by train from town to town, trying to motivate public support. He suffered a severe stroke in Colorado and was incapacitated for the remainder of his presidency. Nevertheless, he refused to let the Democrats vote for a compromised version of the treaty that included the "reservations" introduced by Foreign Relations Committee chairman Henry Cabot Lodge. Lodge's reservations would modify American membership in the League to mandate Congressional approval for United States' participation in certain League measures, such as economic sanctions and military action. The showdown votes came on November 19, 1919. The treaty

with Lodge's reservations was defeated by a combination of Republican "Irreconcilables" who opposed United States' membership in the League under any circumstances and Democrats who dutifully followed Wilson's directives to withhold support from a modified treaty. A second vote on the unaltered treaty was defeated along strict party lines, the two Republican factions, Lodge's and the "Irreconcilables," reuniting for the purpose.

A final vote in March 1920 was anticlimactic, resulting in another defeat for the unbending Wilson and the League. Subsequently, the United States signed a separate peace agreement with Germany that included all the provisions of the Treaty of Versailles except the League of Nations. For Wilson and his followers, the failure was bitter. Others, like those who adhered to the perspective of the *Nassau County Review*, were exultant. For them, ratification of the Treaty of Versailles with the League of Nations was a contest between "Americanism vs. Internationalism." "[A]nd the score was 53 to 38," the paper gloated following the November 19 votes. "It was voted one of the best games ever played by 'Americanism' and the victory assures a complete disaster for the Internationalists. It is rumored that their team will disband acknowledging the superiority of the victors."[274]

The veterans of the largest American military force yet created did not wish to simply abandon their sense of commitment, patriotism and camaraderie once the Armistice was signed. Upon their return home, some ex-doughboys joined the Veterans of Foreign Wars, an organization founded before 1917 but whose numbers were swelled by the large crop of Great War veterans.[275] Probably more joined an entirely new organization.

Even before troops began shipping back to America, Lieutenant Colonel Theodore Roosevelt Jr. and several other officers took the first steps in the founding of the American Legion, an organization that intended to play a role similar to that of the Grand Army of the Republic following the Civil War. Back in the United States, veterans established American Legion posts in cities and town across the country. A meeting was held in Huntington High School in September 1919 with a public invitation for all returned soldiers to join. The organizers hoped that local luminaries like Roosevelt or Colonel Henry Stimson, later Franklin D. Roosevelt's secretary of war, would attend.

Some things had not changed. The racial segregation of the military was replicated in the Legion. Upon their return from service, black and white veterans from Setauket posed together for a photograph on the village green but went on to form separate American Legion posts.

Long Island and World War I

In other ways, the landscape to which the soldiers returned was altered. Women's suffrage was secured, music and fashion had radically changed and the country was preparing to go dry. After the Prohibition amendment was ratified, the *Long-Islander* expressed its satisfaction, stating that the new law was key to fulfilling the nation's "duty of making cleaner towns and cities for our returning soldiers."[276]

The soldiers did not always agree. On April 18, 1919, the *Riverhead News* ran the headline, "Some Here Saturday Preferred Rum to Pink Tea and a Young Riot Followed."[277] Several wounded troops convalescing at Camp Upton had been driven to Riverhead to visit the Soldiers Club, which the village had established for servicemen's recreation. Not satisfied with the club's offerings, they left in the afternoon and "apparently had no trouble obtaining liquor in Riverhead. In fact, they got 'messy drunk.'"[278]

The intoxicated veterans eluded attempts by local officials to round them up and engaged in rowdy behavior on the streets and, later, back at the club. When a lawyer and a clergyman who served as club officers tried to "point out the error of their ways…some of them [the soldiers] used language of the most lurid sort," and one of the soldiers "actually threatened to use his cane on one Riverhead man."[279] Eventually, MPs arrived to help village

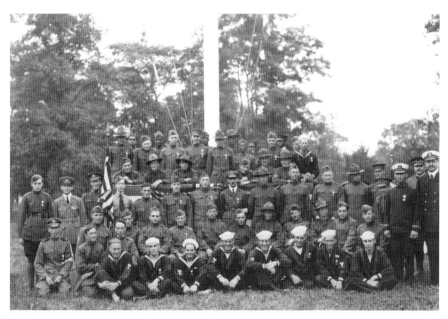

Gathering of Setauket veterans of the Great War. The black and white veterans went on to form separate American Legion posts, circa 1919. *Courtesy of the Three Village Historical Society.*

officials corral the men and take them back to camp. Prohibition was not going to be an easy sell in all quarters.

By 1920, the afterglow of the wartime fervor and triumphalism had begun to fade. The lofty goals of the Wilson administration and the heightened expectations of the public, both fanned by government propaganda, had collided with European power politics. It had become clear that the conflict had not been the "war to end all wars" and that democracy would not triumph across Europe, much less the world. Nevertheless, although they may have questioned their youthful enthusiasm, most of the returned soldiers never lost their conviction that they had fought in a good war, turning back German militarism and imperialism. In response, the public commemorated their service and sacrifice through public ceremonies and the erection of war memorials in virtually every town, village and city. In 1926, Congress, lobbied by the American Legion, declared Armistice Day a national holiday, a position it held until 1958, when it was converted into Veterans Day.

Despite these measures, substantial numbers of the public, veterans or not, returned to the traditional American skepticism toward direct intervention in Europe's quarrels and embraced anew George Washington's axiom to avoid "entangling alliances," a response that helped kill ratification of the Treaty

Victory remembered. A group of Huntington Boy Scouts proudly wearing German spiked helmets, a popular doughboy war trophy, circa 1930. *Courtesy of the Huntington Historical Society.*

of Versailles. In 1920, the American public elected Warren G. Harding, who ran on the slogan, "A Return to Normalcy." Though vaguely stated, it implied that the military and diplomatic intervention into the Great War was an extraordinary circumstance, not readily repeated, and that the country would concentrate on its own interests, while avoiding permanent and continuous involvement with the major powers of Europe.

American foreign policy was not, as often stated, "isolationist." The United States cooperated with the League and maintained a permanent secretary at League headquarters. The nation also took the lead in naval disarmament treaties and arranged loans to resolve European financial crises. Simultaneously, it greatly reduced immigration and in 1919–20 experienced a wave of near hysteria over the perceived rise of radicalism, especially of the communist variety. As the decade wore on, most Americans enjoyed the benefits of prosperity, a ramped-up consumer culture and the loosened social norms and vibrant culture that the war had done much to unleash.

LONG ISLAND'S WAR MEMORIALS

A SELECTION

Great War Memorial, Little Neck, Queens County. *Author's collection.*

Great War Memorial, Glen Cove, Nassau County. *Author's collection.*

Great War Memorial Southampton, Suffolk County. *Author's collection.*

Long Island's War Memorials

Above: Great War Memorial, Eastport, Suffolk County. *Author's collection.*

Opposite: 42nd Division Memorial on the site of Camp Mills, Garden City, New York. *Author's collection.*

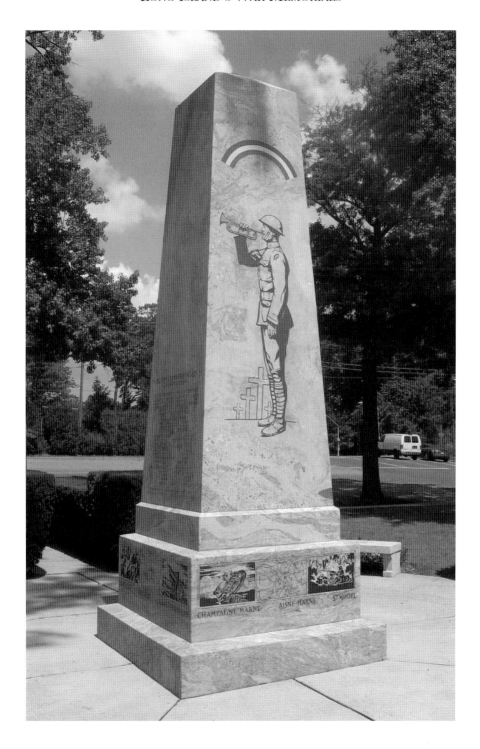

NOTES

Introduction

1. In 1898, New York City incorporated Long Island's two westernmost counties, Kings (Brooklyn) and present-day Queens. While still sharing many of the characteristics of the rest of Long Island, Kings and Queens inevitably absorbed the characteristics of the city to which they were bound by politics, transportation and, increasingly, social and economic forms. While events and personages in the immediate metropolitan area are included where appropriate, the current exploration centers on Nassau and Suffolk Counties.

Chapter 1

2. Sharp, Steins and Pandit, *New York State Population*, 245, 290.
3. Ibid., 20, 245. The total population of New York State stood at 9,113,614 in 1910. Despite the war, the population grew over the succeeding decade. Nassau, for example, jumped from 284,041 to 126,120 between 1910 and 1920. Ibid., 245.
4. Welch, "Thousand-Acre City by the Sea," 116–29.
5. The Central Powers also included the Ottoman empire and Bulgaria.
6. Currie, "Telefunken Radio Station in Sayville," 13.
7. Ibid., 15.

8. Doenecke, *Nothing Less than War*, 187.
9. Wortman, *Millionaire's Unit*, 47–48.
10. Chernow, *House of Morgan*, 200.
11. Ibid., 189.
12. Ibid., 188–89.
13. Doenecke, *Nothing Less than War*, 126.
14. Clifford, *Citizen Soldiers*, 166.
15. Ibid., 186.
16. Ibid., 187.
17. Ibid., 200.
18. Ibid., 188.
19. Ibid., 189.
20. Howlett, "Garden City Hotel and the Modern American Peace Movement," 26.
21. Ibid.
22. The FOR also supported a "League to Enforce Peace," which was very similar to Woodrow Wilson's League of Nations. By 1917, it was also advocating for penal, racial, educational and industrial reform.
23. *County Review*, April 20, 1917, 10.
24. *Long-Islander*, May 10, 1918, 1. The *Long-Islander*'s editors approved a law mandating compulsory military training for boys sixteen through nineteen, arguing that "the lesson of the war shows the need for preparedness. The nation needs to be able to call upon large numbers of men as Germany did. [It is] necessary as a war measure, [but] it will make our boys better physically, more erect in their carriage, manlier, and better members of society."
25. For example, in the first draft call, Suffolk's eastern district required six hundred men to report to the Selective Service board, but only one hundred were accepted. *County Review*, August 8, 1917, 11.
26. *Long-Islander*, June 5, 1917, 1.
27. Ibid., September 2, 1917, 1.
28. Ibid.

Chapter 2

29. Wortman, *Millionaire's Unit*, 58–59.
30. Ibid., 105.
31. Ibid., 111.
32. Ibid. Wortman believes that Davison suffered a panic attack that caused him to mishandle his plane and crash.

33. *Nassau County Review*, November 22, 1918, 1.
34. Ibid.
35. *County Review*, June 21, 1918, 1.
36. Wortman, *Millionaire's Unit*, 136.
37. In the case of the more sparsely populated western states, divisions often comprised the guards of two or three states. The 82nd Division, like the 42nd, was a more heterogeneous formation, hence its nickname, "All American," which was included in its shoulder insignia.
38. Harris, *Duffy's War*, 69.
39. The 1st and 2nd Divisions, made up of regulars; the 26th, the "Yankee Division," composed of New England National Guards; and the 42nd were the only ones that spent the entire winter of 1917–18 in France. While they were mostly involved in advanced combat training, under British and, more often, French oversight, parts of the divisions, especially the "Big Red One," were involved in small, mostly minor combat operations. Because of this early service, they were called the "Old Reliables."
40. *Long-Islander*, July 27, 1917, 6.
41. *County Review*, August 8, 1917, 2.
42. Ibid., October 10, 1917, 1; October 19, 1917, 3.
43. Ibid., November 23, 1917, 6.
44. Ibid.
45. Ibid.
46. Ibid.
47. Ibid.
48. The issue of conscientious objector status proved contentious in the early months of the war, with many government and political figures resistant to the idea. Eventually, the Wilson administration recognized it as valid, but it was generally accepted only for members of religious denominations that had long pacifist traditions.
49. Harris, *Duffy's War*, 104.

Chapter 3

50. *County Review*, March 6, 1917, 1.
51. Ibid., June 26, 1917, 1.
52. The New York State Agricultural School at Farmingdale took an active role in military training, as well as provided organization and know-how to the food production campaign. Captain Peter Maguire, director of

military tactics at the school, sometimes assisted in drilling the Huntington Home Guards. *Long-Islander*, July 27, 1917, 4.
53. *Long-Islander*, May 21, 1917, 4.
54. Ibid.
55. *County Review*, June 22, 1917, 2.
56. *Long-Islander*, September 28, 1917.
57. It soon became clear that threats of German invasion, raids or sabotage were greatly exaggerated. When first organized, a few Home Guards on the East End were sent to guard the bridges over the Shinnecock Canal to prevent their destruction by Germans or German sympathizers. By late summer, they had been withdrawn by the county supervisors, who believed that "there is little danger of Germans or enemies of the United States doing any damage now." *County Review*, August 24, 1917, 1.
58. Ibid., May 21, 1917, 1.
59. *East Hampton Star*, March 8, 1918, 5.
60. *Long-Islander*, August 31, 1917, 5.
61. *County Review*, April 6, 1917, 1. In comparison, the Welin Marine Equipment Company of Long Island City proposed to build three submarine chasers at $89,975 each.
62. *Long-Islander*, November 11, 1917, 1.
63. Finckenor, "Sag Harbor Defense Industries," 24–25.
64. "Well-Worn Ways."
65. Welch, *Island's Trade*, 122–23.
66. Ibid., 124.
67. *Nassau County Review*, June 8, 1917, 7.
68. *Long-Islander*, April 5, 1918, 3.
69. *Nassau County Review*, May 18, 1917, 4.
70. *Long-Islander*, May 4, 1917, 1.
71. *Nassau County Review*, May 4, 1917, 1.
72. Hazelton, *Boroughs of Brooklyn and Queens*, vol. 2, 614.
73. For example, the *Riverhead County Review* ran a food conservation pledge in its July 20, 1917 edition. Those who signed the pledge committed themselves to one wheatless day per week, to economize butter, to limit daily use of sugar, to eat more vegetables, fruit and fish and to urge food economy at home and in their favorite restaurant. The pledges, of course, had no legal enforcement mechanism.
74. The Suffolk County Board of Trustees even authorized sending prisoners from the county jail to work on the county farm at Yaphank. *County Review*, April 27, 1917, 1.

75. *Nassau County Review*, July 19, 1918, 1.
76. By May 1917, the amount of land planted for potatoes had increased fourfold in Suffolk and was expected to yield 300 million pounds of spuds. Riverhead's *County Review* ran stories bearing headlines "The Farmer Must Win the War" and "Potatoes and Patriotism." *County Review*, May 4, 1917, 1, 6.
77. *Long-Islander*, February 21, 1918, 1.
78. Ibid., May 4, 1918, 1.
79. *County Review*, June 7, 1918, 1.
80. *Long-Islander*, February 21, 1918, 1.
81. Ibid., April 5, 1918, 8.
82. Ibid., May 17, 1918, 8.
83. Ibid., August 2, 1918, 8.
84 Ibid., August 23, 1918, 1.
85. For Long Island's farmers as well as the nation generally, the war years were economically bountiful. The overall productivity of American agriculture provided the only real check on profits, and as early as the spring of 1918, Suffolk papers reported that farm profits were down due to overproduction. Still, farmers were exhorted by governmental, economic and social leaders not to cut back on planting. The end of the war brought the good times on the farm belt to a screeching halt, and most farmers were in economic doldrums or worse throughout the "Golden Twenties." *Long-Islander*, April 5, 1918, 8.
86. State interest in a "Women's Land Army" led to some preliminary planning in the summer of 1918. The initiative seems confined to upstate New York, and there is no record of such an organization planned or in operation on Long Island.
87. *County Review*, March 15, 1918, 6.
88. *Long-Islander*, October 19, 1917, 7.
89. Capozzola, *Uncle Sam Wants You*, 46–48.
90. *Long-Islander*, September 14, 1917, 4.
91. Schaffer, *America in the Great War*, 5.

Chapter 4

92. *County Review*, May 4, 1917, 2.
93. *Nassau County Review*, June 8, 1917, 1.
94. Ibid.

95. Wortman, *Millionaire's Unit*, 107.
96. Ibid.
97. Ibid.
98. *Long-Islander*, May 7, 1917, 1.
99. Riverhead held a Red Cross recruitment drive later in May and enrolled four hundred supporters out of a population of five thousand. By June, the town had reportedly raised $3,500 for the organization, while others pledged to knit clothes, socks or bandages for the army. *County Review*, May 25, 1917, 1; June 26, 1917, 1.
100. *Long-Islander*, May 10, 1918, 1; May 31, 1918, 8.
101. Ibid., May 31, 1918, 8.
102. *County Review*, August 9, 1918, 1.
103. Ibid., April 5, 1918, 1; April 18, 1918, 1.
104. *Long-Islander*, July 5, 1918, 3.
105. Ibid., September 21, 1917, 1.
106. Ibid.
107. No known print of *For France* seems to exist, nor have any photographs of its creation surfaced.
108. *Long-Islander*, May 25, 1917. The paper cited the president in an editorial encouraging Long Islanders to subscribe.
109. Ibid., October 5, 1917, 1.
110. Ibid., October 26, 1917, 1.
111. *County Review*, April 19, 1918, 5.
112. Ibid., June 28, 1918, 1.
113. Johnson, *Following the Harbor*, 46.
114. *Long-Islander*, August 27, 1917, 1.
115. Ibid., October 4, 1918, 4; October 25, 1918, 1.
116. Ibid., September 20, 1918, 2.
117. Ibid., October 25, 1918, 1.
118. *Long-Islander*, August 31, 1917, 3.
119. The Long Island Committee for the project believed that it needed $60,000 for the "Hostess House," as well as sponsors from each time. Exactly what the amenities would be was not mentioned.
120. *County Review*, April 12, 1918, 1.
121. *Long-Islander*, September 18, 1918, 2.
122. Johnson, *Following the Harbor*, 45.
123. *Nassau County Review*, June 20, 1919, 1.
124. Hazelton, *Boroughs of Brooklyn and Queens*, vol. 2, 601.
125. *Long-Islander*, June 28, 1918, 3.

Chapter 5

126. Doenecke, *Nothing Less than War*, 132–33.
127. Capozzola, *Uncle Sam Wants You*, 204.
128. Ibid., 184.
129. *County Review*, April 19, 1918, 1.
130. *Amityville Record*, January 11, 1918, 1.
131. Ibid., June 7, 1918, 1.
132. Ibid., April 26, 1918, 1.
133. Ibid., March 22, 1918, 1.
134. Ibid.
135. Ibid., May 3, 1918, 1.
136. Ibid.
137. *Long-Islander*, April 20, 1917, 1. Fullerton's extensive photographic record of Long Island is housed in the Suffolk County Historical Society at Riverhead. It is the largest single collection of photographs of the Island, circa 1890–1920.
138. Ibid.
139. *County Review*, January 11, 1918, 2.
140. *Long-Islander*, August 3, 1917, 2.
141. Ibid., August 31, 1917, 4.
142. Ibid., August 23, 1918, 4.
143. Ibid., July 5, 1918, 1.
144. Ibid., September 7, 1918, 1.
145. Ibid.
146. *Nassau County Review*, December 13, 1918, 2.
147. Ibid.
148. *Long-Islander*, September 6, 1918, 1.
149. Ibid.
150. Ibid.
151. Ibid., August 10, 1917, 1.
152. Ibid.
153. Ibid., July 5, 1918.
154. For a detailed analysis of government operation of the wartime economy see Schaffer, *America in the Great War*, chapter 4.
155. Fears of labor radicalism, already high during the war, intensified after the Bolshevik Revolution and communist takeover of Russia. When railroad workers threatened a mass strike in August 1919, the *Nassau County Review* concluded a denunciatory editorial stating, "If we must have

a revolution let it come now, and determine whether government by the majority is to survive." *Nassau County Review*, August 22, 1919, 4.
156. Ibid., 10.
157. *Long-Islander*, September 28, 1917, 1.
158. Ibid., October 26, 1917, 1.
159. Ibid., August 23, 1918, 1.
160. Ibid.
161. *County Review*, July 13, 1917, 3.
162. Ibid., October 12, 1917, 1.
163. Schaffer, *America in the Great War*, 98.
164. *County Review*, December 21, 1917, 1; February 1, 1918, 1. The White Oak Inn attempted to cater exclusively to officers. Some reports blamed, or credited, the raid on information provided by enlisted men who resented their exclusion.
165. Ibid., December 14, 1917, 1.
166. Schaffer, *America in the Great War*, 101.
167. Ibid.
168. Ibid., 103.
169. *Long-Islander*, July 5, 1918, 1.
170. Ibid.
171. Ibid.
172. Ibid.
173. Ibid., July 12, 1918, 5.
174. Ibid., July 19, 1918, 5.
175. Ibid., July 19, 1918, 10.
176. Ibid.
177. *Nassau County Review*, January 24, 1919, 1.
178. Ibid.
179. Harris, *Duffy's War*, 86.
180. Ibid., 84–85.
181. Ibid., 86.
182. Ibid., 85.
183. Interviews, *Men of Bronze* (movie). Some stated that the men of the 69th deliberately defamed the Alabama men, spreading false tales that they intended attacks. See Harris, *Duffy's War*, 85.
184. *Long-Islander*, April 19, 1918, 1.
185. Ibid.
186. Ibid.
187. *County Review*, June 7, 1918, 1.

188. Ibid.
189. Ibid., May 10, 1918, 1.
190. Ibid., May 17, 1918, 1.
191. Ibid., October 26, 1917, 1.
192. Letter, Albert W. Sells to Bessie Strong, January 12, 1918, Three Village Historical Society.
193. *Long-Islander*, May 4, 1917, 2.
194. Ibid., August 24, 1917, 1.
195. Ibid.
196. Ibid., September 7, 1917, 1.
197. Ibid., December 17, 1917, 2.
198. Schaffer, *America in the Great War*, 97.
199. *Long-Islander*, April 12, 1918, 5.
200. *County Review*, April 19, 1918, 1.
201. Ibid., May 31, 1918, 2.
202. *Long-Islander*, August 9, 1918, 1.
203. *County Review*, October 10, 1918, 1.

Chapter 6

204. Harris, *Duffy's War*, 194.
205. Ibid.
206. Hazelton, *Boroughs of Brooklyn and Queens*, vol. 2, 615.
207. The division's insignia featured a red "NY" on a black background that included the constellation Orion, a play on their commander's name.
208. DeWan, "Memories of the Great War."
209. Ibid.
210. Yockelson, "Brothers in Arms," 110.
211. Hazelton, *Boroughs of Brooklyn and Queens*, vol. 1, 442.
212. Yockelson, "Brothers in Arms," 111.
213. Hazelton, *Boroughs of Brooklyn and Queens*, vol. 1, 453.
214. Father Francis Duffy, chaplain to the 69th/165th, cited in Harris, *Duffy's War*, 211.
215. Ibid.
216. Ibid.
217. *History of the 77th Division*, 206.
218. Hazelton, *Boroughs of Brooklyn and Queens*, vol. 1, 512.
219. Ibid.

220. Swenson, *Diary of World War I*.
221. Ibid.
222. Ibid.
223. Edward Hawkins, "Memories of the Great War," part 2, edited by George DeWan, *Newsday*, November 11, 1981, 4.
224. Harris, *Duffy's War*, 244.
225. Hazelton, *Boroughs of Brooklyn and Queens*, vol. 2, 616.
226. Ibid.
227. Ibid.
228. Interview, William W. Nicoll, in DeWan, "Memories of the Great War," 4.
229. Ibid.
230. Ibid.
231. Ibid. After the war, Nicoll operated a photography business in Jamaica, Queens, and moved to Merrick in Nassau County.
232. Ibid. Swenson returned to Long Island after the war, but, like Whittlesey, he brought the war back inside him. He turned increasingly to alcohol, was subject to violent outbursts and was abusive to his family—all characteristics of PTSD, or "shell shock," as it was known in World War I.
233. Hawkins, *Newsday*.
234. Ibid.
235. United States Army, https://www.army.mil/article/1893921/on-amry-birt.
236. Brad Harris, "News of Long Ago," *Smithtown News*, September 1, 1917.
237. The United States had not yet instituted a full range of decorations to recognize distinct levels of competence, service, leadership or bravery. Only the Medal of Honor, Distinguished Service Cross, Navy Cross (1919) and Distinguished Service Medal were available during the Great War. The Distinguished Flying Cross was created in 1926 and the Silver Star and Purple Heart in 1932. The World War I Victory Medal was established as the war came to an end. Thirteen campaign/battle clasps were authorized for service, although most veterans received only one to five depending on their division's service. The U.S. Navy authorized nineteen different clasps to recognize specific service areas or specialties.
238. The Germans photographed him lying next to his wrecked aircraft before they buried him. In 1944, after Quentin's brother Theodore Jr. had died shortly after receiving the Medal of Honor for his leadership on D-Day, Quentin was exhumed and buried next to Theodore Jr. at the Normandy cemetery.

239. Flying in the delicate, fabric-covered aircraft was a dangerous service even in noncombatant conditions. Two pilots training at Brindley Field, G.S. Gedeon and Harold F. Maxon, were killed in a training accident in 1918. See Muha, "Memorial to Forgotten Fliers."
240. The *San Diego* was commissioned as the *California* in 1907. A battlecruiser, the ship deployed both four- and six-inch guns, as well as smaller armament. In 1914, the vessel was recommissioned the *San Diego* when the navy adopted the policy of naming battleships after states and cruisers for cities. For the material on the navy and scuba divers, the author received personal communications from Bill Bleyer, September 8, 2017.
241. Hazelton, *Boroughs of Brooklyn and Queens*, vol. 1, 452.

Chapter 7

242. *Amityville Record*, November 8, 1918, 1.
243. *Long-Islander*, October 4, 1918, 1.
244. Ibid., October 14, 1918, 1.
245. Ibid., November 1, 1918, 1.
246. *Nassau County Review*, November 8, 1918, 7.
247. Ibid., November 29, 1919, 11.
248. *Long-Islander*, November 15, 1918, 1.
249. Ibid.
250. Ibid.
251. *Amityville Record*, November 15, 1918, 1.
252. *County Review*, November 22, 1918, 1.
253. Johnson, *Following the Harbor*, 46.
254. *Long-Islander*, January 24, March 4, May 5 and June 17, 1919.
255. *County Review*, July 11, 1919, 1.
256. Ibid.
257. Ibid.
258. *Nassau County Review*, September 5, 1919, 1.
259. Ibid.
260. *County Review*, May 9, 1919, 1.
261. Ibid.
262. *Long-Islander*, July 11, 1919, 4.
263. Ibid.
264. *Nassau County Review*, December 13, 1918, 1.
265. Swenson, *Diary of World War I*.

266. Ibid., April 11, 1919, 1.
267. *Long-Islander*, February 21, 1919, 1.
268. Ibid.
269. Ibid., March 14, 1919, 1.
270. Ibid., July 11, 1919, 1.
271. *Nassau County Review*, May 16, 1919, 6.
272. Ibid.
273. Ibid., September 26, 1919, 4.
274. Ibid., December 5 and 12, 1919, 4.
275. For example, in February 1919 the Major General Franklin Bell Post of the VFW was established at Rockville Center. Bell had been the first commander at Camp Upton. *Nassau County Review*, February 14, 1919, 1.
276. *Long-Islander*, February 28, 1919, 1.
277. *Riverhead News*, April 18, 1919, 1.
278. Ibid.
279. Ibid.

BIBLIOGRAPHY

Primary

DeWan, George, ed. "Memories of the Great War." *Newsday*. Part 2, November 10–11, 1981.

Swenson, August Edward. Unpublished diary. Collection of Judith Lee Hallock.

Newspapers

Amityville Record.
Freeport Nassau County Review.
Huntington Long-Islander.
Riverhead County Review.
Riverhead News.

Secondary

Aldrich, Nelson, Jr. *American Hero: The True Story of Tommy Hitchcock—Sports Star, War Hero, and Champion of the War-Winning P-51 Mustang.* Guilford, CT: Lyons Press, 2016.

Bayles, James M. "Well Worn Ways: A Brief History of the Bayles Shipyard on Long Island." Typescript, circa 1960.

Bibliography

Capozzola, Christopher. *Uncle Sam Wants You: World War One and the Making of the Modern American Citizen*. New York: Oxford University Press, 2008.

Chernow, Ron. *The House of Morgan: An American Banking Dynasty and the Rise of Modern Finance*. New York: Touchstone Books, 1990.

Clifford, John Garry. *The Citizen Soldiers. The Plattsburgh Training Camp Movement, 1913–1920*. Lexington: University Press of Kentucky, 1972.

Currie, Constance. "The Telefunken Radio Station in Sayville." *Long Island Forum* 19, no.1 (Winter 1996): 4–16.

Doenecke, Justus B. *Nothing Less than War*. Lexington: University of Kentucky Press, 2011.

Eisenhower, John D. *Yanks: The Epic Story of the American Army in World War One*. New York: Simon & Schuster, 2001.

Finckenor, George. "Sag Harbor Defense Industries." *Long Island Forum* 59, no. 4 (Fall 1996): 22–26.

Fitzpatrick, Kevin. *World War I New York: A Guide to the City's Enduring Ties to the Great War*. Guilford, CT: Globe Pequot, 2017.

Harris, Stephen L. *Duffy's War: Father Francis Duffy, Wild Bill Donovan and the Irish Fighting 69th in World War One*. Washington, D.C.: Potomac Books, 2008.

Hazelton, Henry Isham. *The Boroughs of Brooklyn and Queens: Counties of Nassau and Suffolk, Long Island, New York, 1609–1924*. 2 vols. New York: Lewis Historical Publishing Company Inc., 1925.

History of the 77th Division: August 25, 1917–November 11, 1918. New York: 77th Division Association, 1919.

Howlett, Chuck F. "The Garden City Hotel and the Modern American Peace Movement." *Long Island Historical Journal* 19, nos. 1–2 (Fall 2006/Spring 2007): 20–43.

Johnson, Barbara. *Following the Harbor: Northport Village's First Hundred Years, 1894–1994*. Northport, NY: Incorporated Village of Northport, 1998.

Johnson, Suzanne, and David Clemens. *Camp Upton*. Charleston, SC: Arcadia Publishing, 2017.

Muha, Laura. "Memorial to Forgotten Flyers." *Newsday*, August 17, 1989.

Schaffer, Ronald. *America in the Great War: The Rise of the Welfare State*. New York: Oxford University Press, 1991.

Sharp, Barbara, Janet Steins and Jyoto Pandit. *New York State Population*. New York: Neal Schuman Publishers, 1987.

The 27th Division: Home Again! New York: John H. Eggers, 1919.

Wallace, Margaret E. *America and the Great War*. New York: Bloomsbury USA, 2017.

Bibliography

Welch, Richard F. *An Island's Trade: Nineteenth-Century Shipbuilding on Long Island.* Mystic, CT: Mystic Seaport Museums Press, 1993.

———. "The Thousand-Acre City by the Sea: T.B. Ackerson's Brightwaters." In *Gardens of Eden: Long Island's Early Twentieth Century Planned Communities.* Edited by Robert B. Mackay. New York: W.W. Norton & Company, 2015.

Williford, Glen, and Leo Polaski. *Long Island's Military History.* Charleston, SC: Arcadia Publishing, 2004.

Wortman, Marc. *The Millionaire's Unit: The Aristocratic Flyboys Who Fought the Great War and Invented American Airpower.* New York: Public Affairs, 2006.

Yockelson, Mitchell. "Brothers in Arms: The 27th and 30th Divisions with the British Army in Breaking the Hindenburg Line." In *The American Expeditionary Forces in Memory and Remembrance.* Edited by Mark Snell. Kent, OH: Kent State University Press, 2008.

INDEX

A

Allies 17
American Ambulance Field Service 17
American Expeditionary Forces 40, 84
American Federation of Labor 72
Americanization 27, 57, 69, 70
American Legion 93, 110, 112
American Protective League 53
American trade 18
Amityville 67, 68, 98, 100
Anti-Enlistment League 24
anti-German animus 62
Armistice 53, 91, 98
Army Air Service 31, 92
Atwater, David 84

B

Babylon 26
Bayles Shipyard 45, 46, 102
Baylis, Hiram E. 80
Bay Shore 29
Belgian Relief Commission 48
Belgium 17
Bell, General Franklin 38

Berlin, Irving 36
Bijou Theater 101
Black Tom 20, 66
Bliss Torpedo Company 57, 60
Bolshevik Revolution 11, 67
boys' camps 50
Boy Scouts 50, 59, 70, 101
Bradford, First Lieutenant Waillium 85
Brightwaters 16
Brindley Field 33, 64, 75, 101, 106
British blockade 19, 20
Brookhaven 26
Brookhaven National Laboratory 106
Brooklyn Eagle 80
Bureau of Returning Soldiers and Sailors 105

C

Calverton 35
Campfire Girls 59
Camp Mills 34, 36, 37, 64, 76, 106
Camp Upton 35, 36, 37, 43, 57, 63, 73, 75, 78, 97, 101, 106
Camp Wadsworth 28
Castledge 29

INDEX

Center Moriches 64
Centerport 80, 102
Central Powers 17, 98
Chateau-Thierry 86
Commack 75, 106
Committee of Fourteen 73
Committee on Public Information 53, 57, 62
Committee on Training Camp Activities 74
conscientious objectors 39
County Review 37, 55
Creel, George 53
Crossley, A.L. 49, 50

D

Davison, Henry P. 19, 28, 56
Davison, Kate Trubee 56
DeBevoise, Major C.B. 42
Derby, Ethel Roosevelt 102
Doubleday, Russel 44
draft 26
Duffy, Father Francis 77

E

Eastern Shipping Company 44
Easter Rebellion 17
East Farm Canning Kitchen 48
East Hampton 16, 43
Eastport 64
Ellis Island 67
Emergency Fleet Corporation 45
Espionage Act 54, 67, 69
Ettinger, Private Al 84
E.W. Bliss Company 44

F

Farmingdale 49
Far Rockaway 60
Fellowship of Reconciliation 24
Ferguson, Mrs. J.A. 63

15th New York 79
15th New York/369th U.S 77
15th New York National Guard 37, 38, 73
Fire Island 93
Flushing 60
Food Administration 48
Food Control Act 80
For France 57
Fort Terry 22
42nd "Rainbow" Division 26, 28, 34, 40, 76, 85, 86, 97
Fosdick Commission 74, 76
Fourteen Points 21, 99
4th Alabama/167th U.S 76
France 17
Freeport 46, 48, 64, 76, 104
Friends of Germany 68
Fullerton, Hal B. 68

G

Garden City 44, 85
Garden City Hotel 24, 40
German-American Alliance of Amityville 68
German Americans 17, 19, 66, 68, 81
German American soldiers 70
German language 67
Germany 17, 18
Girls' Radio Unit 29
Glen Cove 105
"Gold Coast" 16, 19, 28
Grand Army of the Republic 55
Great War 11
Greenport 55
Greenport Basin and Construction Company 44

H

Harby, M.E. 75
Harding, Warren G. 113
Harrity, Mrs. J. 78

138

INDEX

Hawkins, Edward L. 85, 90
Hazelhurst Field 31, 106
Hecksher, August 69
"Hello Girls" 51
Hempstead 77
Hitchcock, Lieutenant Thomas, Jr. 93
Hogan, Corporal Martin 90
Hollis 77
Home Guards 41, 42, 43, 44, 55, 57, 59
Hoover, Herbert 48, 71
Huntington 26, 29, 41, 56, 57, 82, 100, 101
Huntington Bay 29, 69
Huntington Board of Health 74
Huntington Historical Society 104

I

Industrial Workers of the World (IWW) 27, 42, 72
Irish 16
Irish American 17
Islip 26
Islip Terrace 67

J

James, Private Layton 78
Jewish War Board 64
Johnson, A.A. 49
Johnson, Brigadier General Evan M. 104
Johnson, Private Alexander 78

K

Kings County 15
Knights of Columbus 36, 64, 101, 104

L

Lafayette Escadrille 17, 93
Lamont, Thomas 19
Lansing, Secretary of State Robert 21

Lattingtown 29
League of Nations 99, 106
Liberty Loan 53, 58, 59, 60, 62, 104
Locust Valley 105
Lodge, Henry Cabot 109
Long-Islander 47, 49, 51, 61, 70, 71, 72, 77, 99, 108
Long Island Food Battalion 49
Long Island Railroad 37, 44, 63
"Lost Battalion" 88
Lufbery Field 33, 64, 106
Lusitania 21
Lyceum Theatre 73

M

Maloney, Private Michael 78
Medford 73
Meuse-Argonne 86, 99, 106
Miller, Captain James Ely 92
"Millionaire's Unit, the" 28
Mineola 31, 105
Mitchel Field 31, 37, 106
Morgan, J.P. 19

N

Nassau 15
Nassau County 13, 56, 100
Nassau County Review 47, 109, 110
National American Woman Suffrage Association 51
National Army 28, 35
National Guard 24, 34, 41
naval blockade 47
Naval Militia 44
Naval Reserve Aero Squad 28
neutral nations 18
Newton, William C. 64
New York Guard 41
New York Naval Militia 29
New York's Boys Working Reserve 49
New York State Agricultural School at Farmingdale 49

139

INDEX

New York State Guards 44
Nicoll, William W. 91
93rd Division 79
Northport 45, 46, 60, 64, 101
North Shore 15

O

Old Westbury 16, 93
O'Neill, Richard 85
O'Ryan, Major General John F. 84, 85
"Over Here, Over There: Long Island in the Great War" (exhibition) 12
Oyster Bay 38

P

Palace Theater 56, 81
Patchogue 64, 67, 78, 81, 105
Paul, Alice 51
Peacock Point 19, 28, 31
Pershing, General John J. 75, 84
Plattsburgh 22
Plattsburgh Movement 22
Port Jefferson 45
Preparedness movement 21, 23, 25, 28, 38, 81
Progressivism 71
Prohibition 79, 80, 81, 82, 97, 111, 112
prostitution 74

Q

Queens 15

R

Recreation Room and Canteen 64
Red Cross 31, 50, 56, 57, 67, 84
Red Hook 78
Reserve Officer Training Corps (ROTC) 24

Riverhead 37, 57, 63, 81, 82, 100, 105, 111
Riverhead News 111
Roosevelt, Archibald "Archie" 102
Roosevelt, E.F. 58
Roosevelt Field 106
Roosevelt, Kermit 102
Roosevelt, Lieutenant Colonel Theodore, Jr. 102, 110
Roosevelt, Mrs. W. Emlen 63
Roosevelt, Quentin 93, 102, 106
Roosevelt, Theodore 21, 23, 38, 39, 93
Royal Navy 18

S

Sag Harbor 44, 60, 69
Salvation Army 50, 63, 84
Sayville 81
Sedition Act 54, 67, 72
Selective Service Act 73, 80
Selective Service System 26
Sells, Albert W. 79
Service of Supply (SOS) 83
Setauket 16
77th Division 26, 36, 83, 86, 89, 97, 104
shell shock 105
Shepard, Charles E. 80
69th New York 40, 83
69th New York/165th U.S 76
69th/165th Infantry 83
69th/165th Regiment 86
69th Regiment 34
slacker 53
Smithtown 26, 92
Social Welfare Association of Nassau County 105
Soldier's Club 63
South Fork 16
South Shore 16, 18
Spanish influenza 53, 63
Spartanburg, South Carolina 28, 79
Stimson, Colonel Henry 110

INDEX

Stony Brook 16, 48
submarine warfare 20, 24
Suffolk 15
Suffolk County 26, 56, 100
Suffolk County Board of Supervisors 41
Suffolk County Historical Society 12
Suffolk Farm Bureau 50
Swenson, August Edward 89, 91, 106
Swezey, Sylvester 73

T

Telefunken 18
369th Regiment 78
369th United States Infantry. *See* 15th New York
Treaty of Versailles 99, 110
"Trophy Train" 63
Trubee, Davison Frederick 28, 31, 34
27th Division 28, 79, 83, 97

U

U-boats 20, 24, 66, 93
United States Food Administration 48, 71
USS *Agamemnon* 97
USS *San Diego* 93

V

Vesle 86
Veterans of Foreign Wars 110
Victory Arch 97, 104
Victory Loan 104
Vitagraph Film Company 57

W

War Camp Community Service 104, 106
War Camp Community Service Club 64, 76
War Industries Board 71
War Work Week 100
Western Front 24, 25
West Sayville 18
Whitman, Governore Charles 41
Whittlesey, Major Charles S. 88, 105
Wilhelm II, Kaiser 60, 62, 81, 98, 100, 101
Wilson administration 20
Wilson, Woodrow 17, 21, 23, 25, 51, 59, 66, 68, 99, 106, 108, 110
Woman's Christian Temperance Union (WCTU) 80
Women's Naval Service Inc. 57
Women's Relief Corps 55
Wood, General Leonard 22
world war 11

Y

Yale Aero Unit 28
Yale Naval Reserve Unit 69
Yaphank 35, 38
Yip Yip Yaphank 36
Young Men's Christian Association (YMCA) 23, 36, 37, 39, 63, 64
Young Women's Christian Association (YWCA) 56

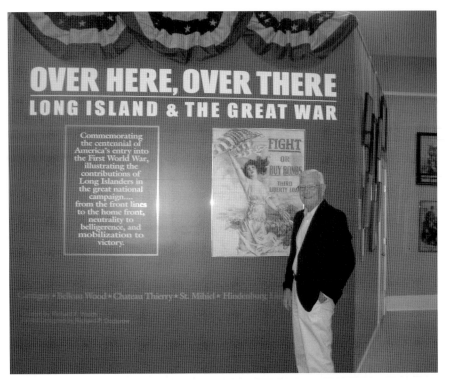

ABOUT THE AUTHOR

A Long Island Native, Richard F. Welch received his doctorate in American history from Stony Brook University. He taught United States History, Western Civilization, Irish History and American Military History at Long Island University and Farmingdale State College.

Dr. Welch is the author of numerous articles and book reviews. His work has appeared in the *Long Island Historical Journal*, *Journal of the American Revolution*, *America's Civil War*, *Civil War Times*, *Military History*, *American History* and the *New York Times*. He is also the author of five books, including *The Boy General: The Life and Careers of Francis Channing Barlow* and *General Washington's Commando: Benjamin Tallmadge in the American Revolution*. He was also a contributor to the *Encyclopedia of New York State*.

A frequent lecturer, Dr. Welch has also worked as a museum exhibition curator and is a member of several historical societies and organizations. He also serves on the board of directors of the Suffolk County Historical Society. He resides in Northport, Long Island, New York.

Visit us at
www.historypress.net